G000168484

SUNDERLAND

STUART MILLER AND JOHN BRANTINGHAM
ON BEHALF OF LIVING HISTORY NORTH EAST

The
History
Press

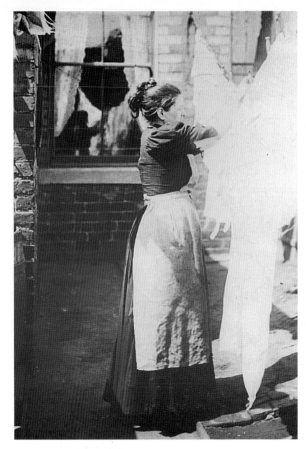

Mrs Allen hangs out the washing, 1897. This is one of those rare shots taken in a cottage backyard – in Paxton Terrace near Diamond Hall. A wash day was a big job though: 'On wash days I remember mother went to grandmother's with me Aunt May. The pair of them were up at 4.30 in the morning stoking the old boiler fire ... Then taking turns – one carrying the empty pail, the other carrying the pail filled with water to fill the poss tub ... All the clothes would be thrown into the tub and possed up and down alternately. After they would wring the clothes out by hand.' (Mrs Robinson)

First published 2010

The History Press
The Mill, Brimscombe Port
Stroud, Gloucestershire, GL5 2QG
www.thehistorypress.co.uk

© Stuart Miller and John Brantingham, 2010

The right of Stuart Miller and John Brantingham to be identified as the Authors of this work has been asserted in accordance with the Copyrights, Designs and Patents Act 1988.

All rights reserved. No part of this book may be reprinted or reproduced or utilised in any form or by any electronic, mechanical or other means, now known or hereafter invented, including photocopying and recording, or in any information storage or retrieval system, without the permission in writing from the Publishers.
British Library Cataloguing in Publication Data.
A catalogue record for this book is available from the British Library.

ISBN 978 0 7524 4927 2

Typesetting and origination by The History Press
Printed in India by Aegean Offset Printers, New Delhi

CONTENTS

ACKNOWLEDGEMENTS

Our thanks are due especially to:

Colin Orr for help with the Colliery Communities section, when he might have much preferred to listen to the second Ashes Test at Lords; Fred Bewick for his unerring eye for detail and astonishing memory of life in old Sunderland; Tom Buckley for generously lending books from his personal collection; Norman Potts for help in interpreting some of the Hendon pictures; Janette Hilton, the manager of LHNE for her unflappable manner, help and encouragement; Sharon Vincent for her help and advice and the example she sets in accuracy of research; Harry Vincent for his help with exasperating technology; Rosie Callaghan and Kate Hilton for that youthful enthusiasm for history which revitalises that of adults; Sunderland Antiquarians for permission to include several of the photographs in their excellent collection; Bill Hawkins for supplying photographs and knowledge; Fred Bewick for supplying pictures.

Finally, to the volunteers of Living History North East for their good companionship and general involvement in the activities of the organisation.

LIVING HISTORY NORTH EAST

Nowadays there is much greater emphasis upon the importance of oral history as a historical source, particularly about the lives of ordinary people. Modern techniques, training and equipment mean that coverage is much more comprehensive and sensitive. As the pace of change hastens there is far greater awareness of the need to capture memories of the nearer past before they disappear. In the forefront of changing attitudes to the role of oral history are many voluntary organisations such as Living History North East.

LHNE was formally established in 1995 when a number of passionate enthusiasts became increasingly aware of the void in recorded memory, not just in Sunderland but across the region. There was a great sense of urgency as we approached a new millennium that the social, economic, political and environmental climate had changed considerably. Sunderland had lost its heavy industries suddenly and there were very few historical footnotes to the thousands of men and women who had spent their lives working in or alongside mining, shipbuilding and construction. It was this sense of 'injustice' in historical materials that initiated the creation of LHNE. From those early formative days we have continued in our pursuit to place the collection and documentation of oral history within the region on the map. Consequently, in 2007 LHNE opened the region's first oral history centre to reflect the unique cultural heritage of the North East.

THE DEVELOPMENT OF SUNDERLAND

The modern history of Sunderland starts in the late sixteenth century with the production of salt from brine, which provided a stimulus to the development of a coal export trade. On the basis of ample supplies of coal, other industries rapidly emerged, including the production of lime, alum, copperas and glass. The reluctant royalism of that old opponent Newcastle, and a brief monopoly of the coal trade to London during the Civil War, considerably stimulated the prosperity of the port of Sunderland and the adjacent village of Bishopwearmouth.

The key to this prosperity was not coal mining (the Wearmouth Colliery did not produce its first shipment until 1835) but the coal export trade, co-ordinated by wealthy fitters who brought together the specialisms of the keelmen, casters, trimmers and ballast men, and arranged colliers. One of the greatest obstacles to this trade had been the state of the river, but with the establishment of the River Wear Commissioners in 1717 there started the long process of adapting the harbour to the needs of the business community.

The river was also a considerable obstacle to land communication. The famous iron bridge was not completed until 1796; renowned not only for its technology but even more for the controversy over the identity of the designer (commonly thought to be Thomas Paine, but actually Rowland Burdon). Economic growth and the changing pattern of communications affected the spatial development of the community. The first half of the nineteenth century saw a tendency for better-off people to move away from their fine town houses in the commercial part of Sunderland to live in the more fashionable Bishopwearmouth, a process described here by observer Dr Barry: 'As soon as a man ... feels that he can live at ease he retires to the parish of Bishopwearmouth which comprises the elevated part of the town, wide clean streets and grand houses – in short the West End.'

With the building of the bridge, the axis of the town tended to swing away from the High Street and Low Street line to that along Fawcett Street and North Bridge Street. The bridge, the docks and the sinking of the Wearmouth Colliery also stimulated the growth of the rather decayed Monkwearmouth. By the middle of the century the middle-class flow was continuing into Hendon and Grangetown, a movement reflected in the survival of much fine terraced housing.

The corollary of this was the decay of the older, overcrowded working-class areas in the East End, moving Dr Francois Magendie to protest in 1831 at 'a picture of wretchedness, filth and poverty.' It was here that the first outbreak of cholera in the UK occurred in 1831. Despite improvements in sanitation and the redevelopment of the East End from 1851 by the new Municipal Corporation, established in 1837, by the end of the nineteenth century Sunderland still had the highest infant mortality rates in the country and unimaginable depths of squalor persisted.

By this time the wealth of the town was associated more with shipbuilding, and especially with large numbers of small, cheap coastal vessels. As the technology changed,

from wood and sail to iron and steam, the yards of Sunderland adapted accordingly. By the early twentieth century 20,000 men, or about two-fifths of the male labour force, were employed in the industry, and the wealthy shipbuilders were the patrons of art and architecture. However, dependence on the staple industries of coal exporting and shipbuilding left Sunderland very vulnerable in the inter-war depression years.

These years saw the soup kitchens and dole queues, as well as the start of the building of extensive council estates and attempts to diversify the local economy by introducing new light industries on trading estates. Full employment returned with the outbreak of war, but the corollary of this was that wartime conditions maintained a level of protection for relatively inefficient and high cost firms so that when peace returned so did most of the old problems. The post-1945 period has been one of long, and often painful, adjustment during which much of the old community has disappeared but the benefits have not always been obvious.

This selection of photographs spans the period from the 1880s to the 1950s and illustrates aspects of the history of Sunderland.

PHOTOGRAPHS AS HISTORICAL EVIDENCE

There is no doubt as to the value of photographs in revealing aspects of life and labour in graphic form in a way which cannot be matched by documentary archives, however detailed. However, while it is true that 'the camera cannot lie', this does not mean that photographs should always be accepted at face value as a truthful record.

The most obvious flaw is the frequent absence of supporting documentary information. The average amateur photographer does not methodically record life for posterity but shoots off 'snaps' of family, friends and scenes and frequently writes no supporting caption. Relatively few people take photographs on behalf of future historians, and since amateur photographers are usually very familiar with their subjects they feel no need to scribble down a description.

Apart from the fact that the interpreter of photographs may have no documentary evidence at all as to who took a photograph, why it was taken and what is shown, there are other problems arising from the selection of subjects which are caused by technological factors and by human propensities.

The main technical problems were the sheer bulk of photographic equipment, the length of exposure times and lighting. By the end of the nineteenth century the process was considerably simplified, but it was still prolonged and obvious enough to allow people to fix their poses and become totally self conscious. Even though suitable internal lighting apparatus was available by the 1880s, it was cumbersome and not for the amateur. The result is that there are relatively few interior photographs.

There is also the possibility of human manipulation. An example is William Waples, some of whose photographs are included in this collection, who spliced in better quality sky when nature had not been adequately forthcoming. There are no obvious examples here of the use of canvas backdrops or the deliberate dressing-up of subjects, in the way which led Dr Barnado to become involved in a famous nineteenth-century court case. However, one must mention in this context the deliberate marshalling of schoolchildren in class photographs so as to hide the shabby and shoeless at the back, or dressing them up from the contents of a 'slop chest'.

It is in the actual selection of subjects that the photographer can, often quite innocently, convey impressions which lead to misinterpretation and create illusions. The ordinary amateur photographer, with the cost of film in mind and an urge to record the memorable, will usually spurn the mundane and commonplace in favour of unusual incidents and people, happy family occasions and picturesque scenery. This selectivity can be misleading for the historian.

For instance, the very high proportion of seaside photographs easily creates an impression of a prolonged summer holiday, a Golden Age. There are many photographs of seaside scenes at Sunderland taken by both amateurs and professionals. In fact they were taken to be converted into postcards for general sale. Similarly, there are large numbers of photographs of carnival days in the East End and Hendon. Not every day of the week was spent at the seaside or in street carnivals however!

Freak and exceptional events encourage a similar distortion. Crashed tramcars, for instance, were popular with photographers, but there weren't really so many. The large number of photographs of celebration days which survive, such as the coronation and silver jubilee of King George V, suggest that Sunderland was constantly garlanded in flags and bunting.

Nor do the mundane aspects of everyday life produce many photographs. It is surprising that any pictures of the very typical back lanes of Sunderland survive, and unusual that they were taken at all. Even then one must be cautious. William Waples, for instance, took many photographs in the 1920s and '30s of the crowded dwellings, courts and alleys of the old East End of Sunderland, and these emphasize decay and squalor. However, many of these look so squalid simply because they were being cleared and demolished. Waples was photographing them before they disappeared. Neither Waples nor the largely male photographers of the late nineteenth century would deign to waste film on such everyday scenes as a woman doing her washing, although one such photograph is included (*see* page 2). Backyards and back lanes do not normally attract photographers either, although they were such an important element in working class lives. There are several here.

Lack of consideration for future historians persists. Most family photographers continue to practise their craft in the same unhelpful way. The future will be well endowed with photographs of children's birthday parties, and of outings to the countryside, theme parks and leisure centres. The rise of the modern digital camera simply aggravates the problem. Many of the issues referred to above equally apply but, in addition, vast numbers of digital photos will never be printed off at all. However, all of this simply makes the attempt to picture the past through old photographs even more intriguing.

1

RIVER, RIVER BANK
AND HARBOUR

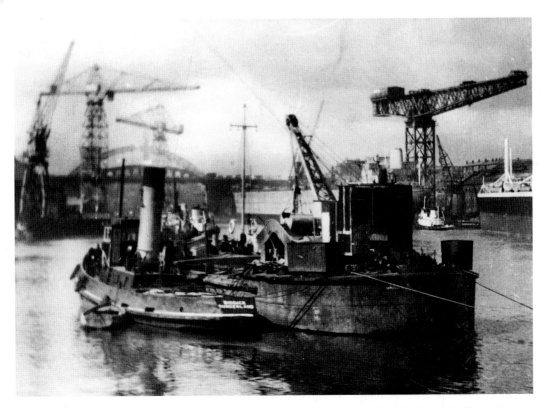

The River Wear Commissioners' tugboat, *Biddick*, standing alongside a dredger. The limit of jurisdiction of the River Wear Commissioners was Biddick Ford.

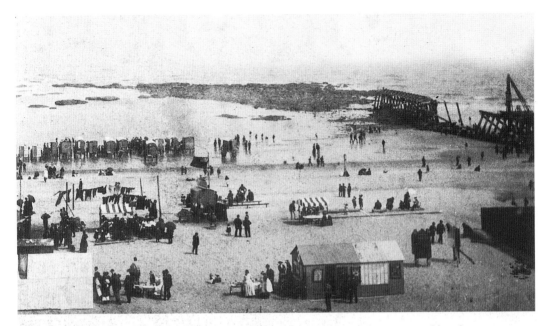

Start of work on the Roker Pier. Work began on the North Breakwater in 1885. Building began on the natural rock outcrop and foundations of rubble and cement were laid to support great blocks of up to 56 tons. The final blocks were put into position in 1902. The 2,800ft-long breakwater with its distinctive red and white granite lighthouse was opened in September 1903.

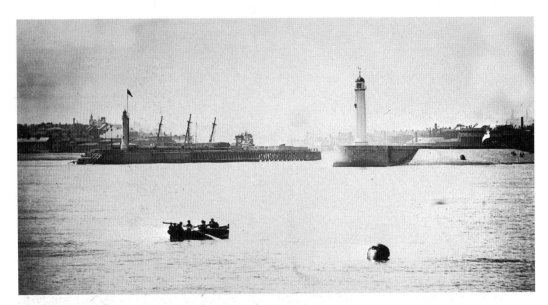

Entrance to the harbour. The lighthouse on the inner North Pier was erected 1801-2. It was 76ft in height and octagonal in form. In 1841 the pier was extended by John Murray, who was responsible for the astonishing feat of moving the iconic lighthouse to the new pier end. In 1856 it was matched by a fine wrought-iron lighthouse on the South Pier. When this became redundant in the 1980s it was moved to its new site overlooking Roker Beach. The inner South Pier dates from the 1720s and the North Pier was built in the 1780s.

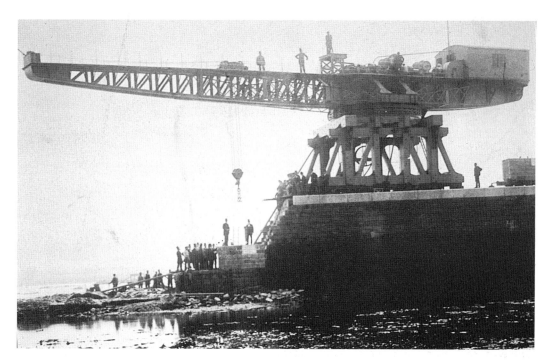

The Roker Pier and the South Pier were both built using this huge crane, suitably called Goliath, to put the great stone blocks into position. The 290 hydraulic crane became a landmark for the town and provided entertainment for beach idlers for many years.

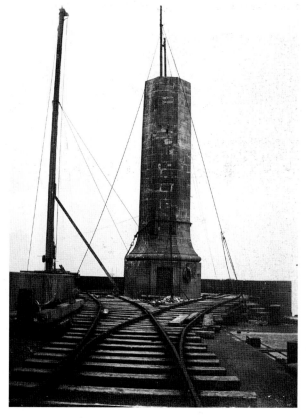

The removal of the old Pickernel lighthouse. Harbour works in the 1890s, including the deepening of the channel, began to have an alarming effect on the old Pickernel-built North Pier lighthouse. It began to tilt, and splits began to appear in the round-head of the pier. The result was that it had to be removed in 1902.

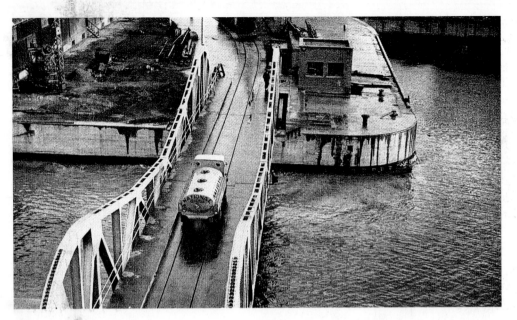

The new aluminium bascule bridge, seen here in 1949. This was erected in the South Dock in 1948 and was the first aluminium alloy bascule bridge in the world. However it corroded badly.

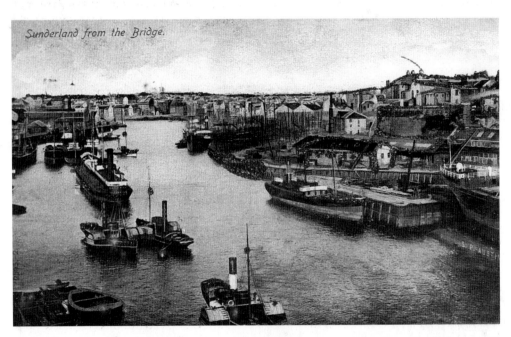

General view downstream from Wearmouth Bridge. This is from a postcard post-marked 1906. To the right is S.P. Austins. Just in view at the bottom right-hand side is the stern of a vessel on the distinctive Austin's pontoon which opened in 1903 and was capable of taking vessels up to 400ft in length. The graving dry dock just beyond the small vessel is empty. In the far background is the old Sunderland quayside, to the left are two Lambton and Hetton paddle tugs and beyond is a distinctive Doxford's turret ship.

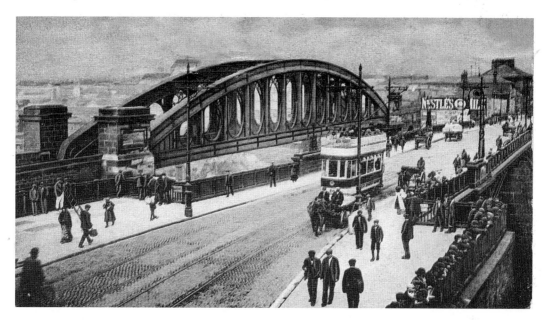

The Stephenson Wearmouth Bridge. Until 1895 the tramways of Sunderland were run by the Sunderland Tramways Company under lease from the Corporation. By March 1900 the system was taken over by the Corporation – at a cost of £35,000. In July of the same year, the first delivery of the new electric tramcars was taken. The first one ran in August 1900 with an eleven-year-old girl becoming the first passenger.

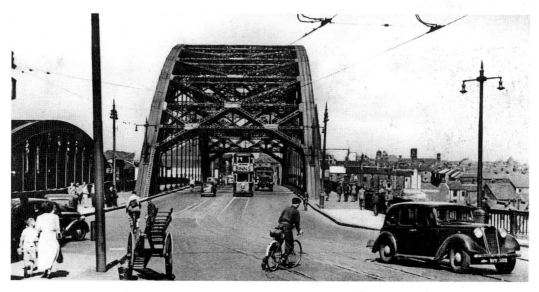

Wearmouth Bridge. Actually this is the third version of the Wearmouth Bridge. The first, completed in 1796, was the second iron bridge in the world. The second version of the bridge was built by Robert Stephenson in 1858-9. This one was built in 1927-9 and has attracted its share of suicides. In fact, external barriers were put in place after the war – allegedly to prevent disillusioned Sunderland supporters from hurling themselves into the billowy depths.

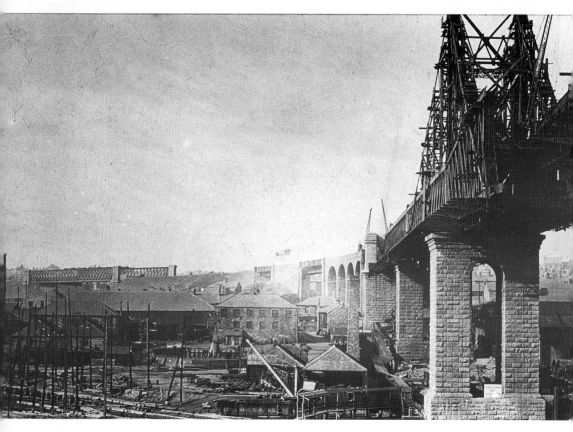

Construction of the Alexandra Bridge. The bridge was designed by Charles A. Harrison and constructed by William Arrol and Co. Ltd. It was designed to carry coal trains from west Durham *en route* to the South Dock. By the time it was opened in 1909 the coal traffic had started to decline and the 'double-decker' bridge was something of a white elephant.

Opposite, above: South Hylton Ferry. Until 1796 the ferries at South Hylton served the main route between Sunderland and Newcastle. The chain-operated ferry was used for vehicles and the rowing boat for passengers. The latter remained in use until 1957. In the background is the Shipwrights Arms which, together with the Golden Lion, served not only the ferry trade but also the keelmen who journeyed up and down the river.

Opposite, below: Laing's Shipyard, 1950. Laing's commenced shipbuilding in 1793 and had one of the longest unbroken periods of shipbuilding. In 1818 they moved to Deptford and in 1853 they launched their first iron vessel but continued to build composite vessels (iron-framed and wooden planked) including the famous Torrens clipper. When steel was introduced Laing's moved into building oil-carrying ships. In 1945 Cunard's placed their first post-war order with Laing's. Here is a 23,000-ton tanker being constructed.

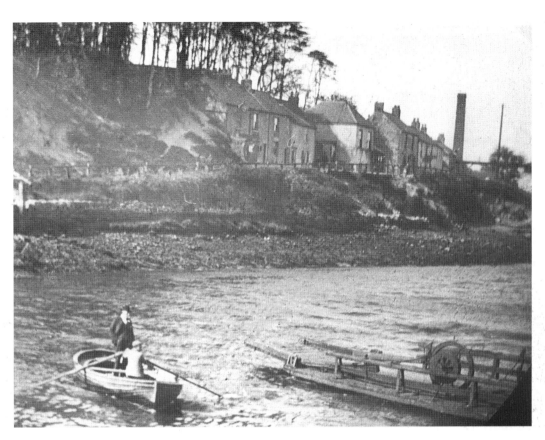

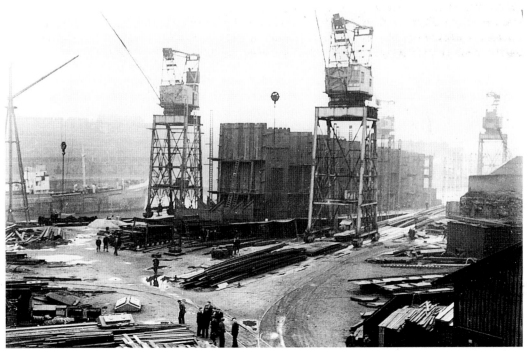

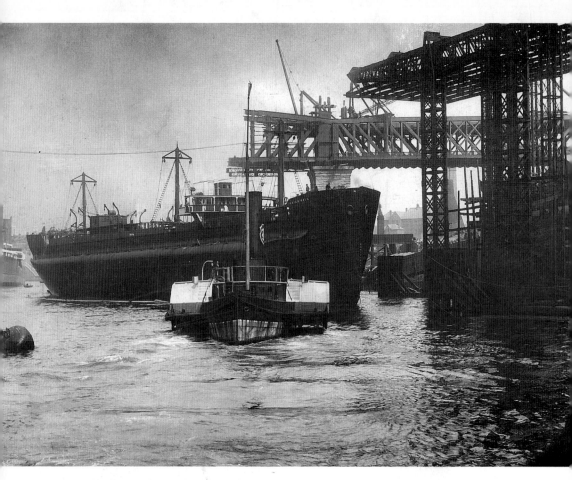

Turret ship at Doxford's. In the background is the Alexandra Bridge under construction in 1908. The turret ship, *Haigh Hall*, was torpedoed and sunk in the Mediterranean during the First World War. Turret ships were modelled on the US whaleback vessel style and had hulls like a flattened cigar. The superstructure was in round or oval 'turrets'. In 1893 Doxford's built their first one. Turret deck ships had a low net tonnage and the method of measurement used at the Suez Canal to determine tolls was originally based on net tonnage; turret ships therefore paid less in tolls than conventional ships of the same capacity. In 1911 the toll measure changed and construction of the type ceased. One hundred and seventy-six had been built before the design was abandoned by William Doxford & Sons.

Opposite, below: Mishap at North Hylton. This area was once heavily industrialised. In 1954 there were half a dozen shipyards in the area (including the original Bartrams). Long before that the Shipwrights Arms, and the Golden Lion on the opposite bank, were part of the chain of inns serving the needs of keelmen. The Shipwrights Arms was one of nine pubs which were condemned by magistrates in 1928 for operating a system of women's 'boxes'– a method of saving small amounts of money each week then having a pay-out at the end of the year. The Licensing Sessions claimed that this encouraged women to frequent public houses. The practice was dropped the following year.

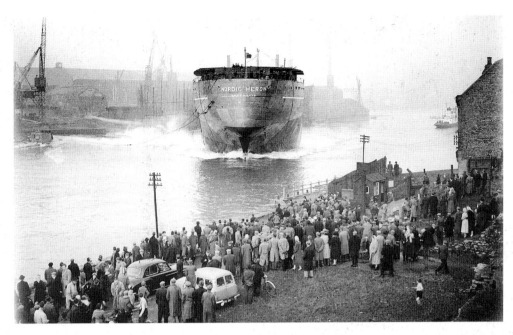

The launch of the *Nordic Heron*. Robert Thompson began building ships in 1846 at the North Sands. In 1854 one of his sons, also called Robert, left to start up on his own at Southwick, having bought the shipbuilding yard of John Candlish. In 1860 Robert Thompson died and the North Sands yard was taken over by Joseph Lowes Thompson, whose other brother, John, also moved away to start a yard at the North Dock. In 1862 J.L. Thompson moved to Sand Point and from 1871 was building iron ships. By the 1890s the firm was fourth in world output. This is a fine example of a launching in 1958 from J.L. Thompson's.

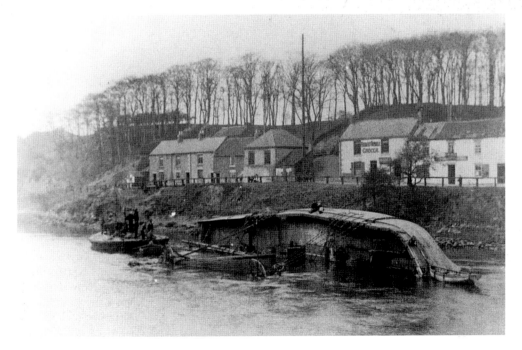

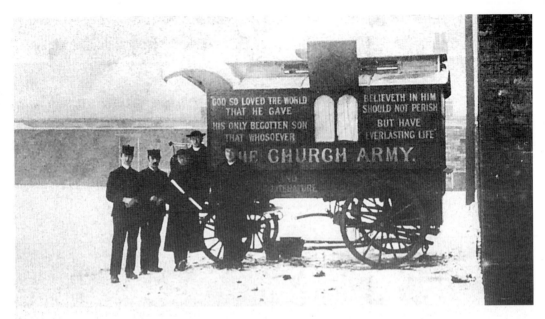

The Church Army at Deptford. Salvation on a snowy day.

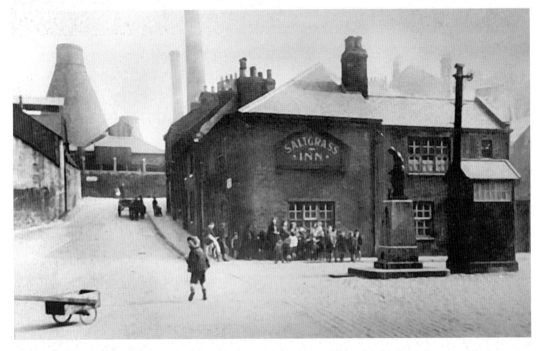

The Saltgrass Inn, in Hanover Place, takes its name from the tidal wetland along the riverside. It is one of many pubs which were to be found in the Ayre's Quay area, meeting the needs of the workers from various industrial premises. The police box was installed in 1923. Chief Constable Crawley introduced these to cut down on the cost of police stations. Twenty-two boxes were installed originally with a telephone in each one; others were added later. They were made to order by Binns for £12 18s 6d each.

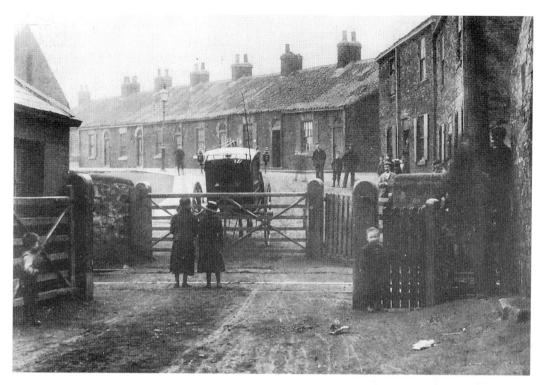

Deptford railway crossing. The striking feature here is the state of the road.

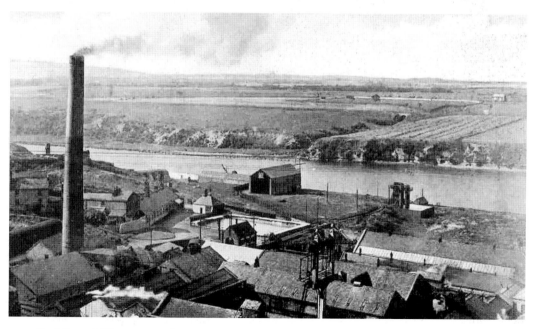

Ford Paper Mill was opened in 1838 by Vint, Hutton & Co. to produce paper from rags. In 1839 it had been taken over by Thomas Routledge, who pioneered the use of esparto grass. It was partly burnt down in 1887 then rebuilt. The Ford Paper Mill continued to operate until 1971.

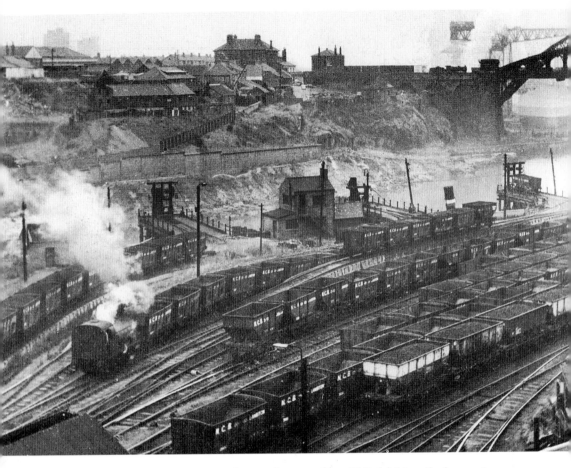

Lambton Coal Staithes, 1966. The Lambton Collieries were at Philadelphia – the locomotives were built at the works of the firm but Sunderland produced the rail and track components. The Lambton Drops stood next to the Hetton Drops. Coal was 'teamed' into waiting vessels by a 'teamer' who knocked a bar which opened the bottom of the wagons.

Opposite, above: The Green, Southwick, *c.* 1950. The building on the left was the Co-op. Stoney Lane leads off to the left.

Opposite, below: The bombed Jack Crawford, which stood in Whitburn Street. It was named after the great Sunderland hero Jack Crawford – who nailed the flag to the mast at Camperdown. The pub was destroyed in an air raid in the Second World War. However, the splendid carving of Crawford performing the deed is now held by Sunderland Museum.

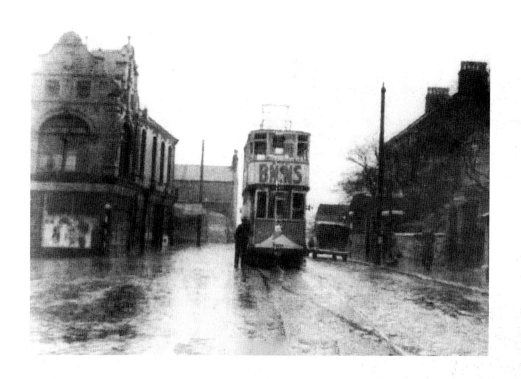

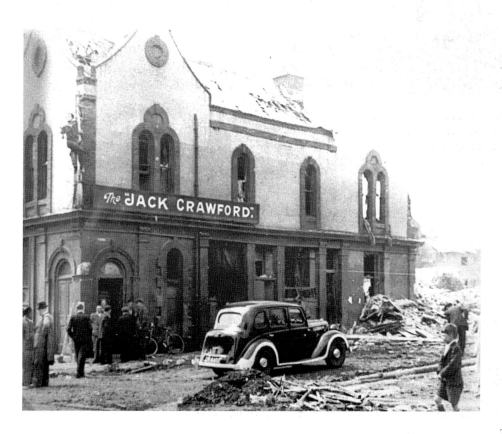

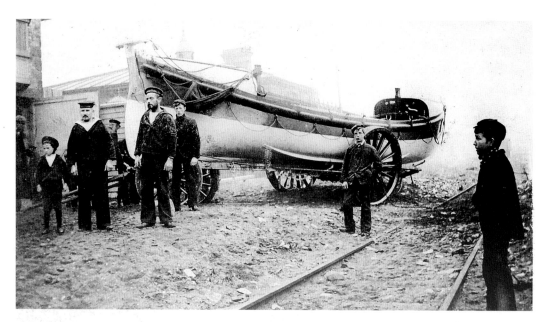

The South Pier lifeboat at Roker in 1905. In the same year the South Outlet lifeboat house was destroyed by fire. In 1912 the South Outlet and Hendon Beach stations were closed and in 1915 a new lifeboat house and slipway on a piled structure were completed at a cost of £2,000.

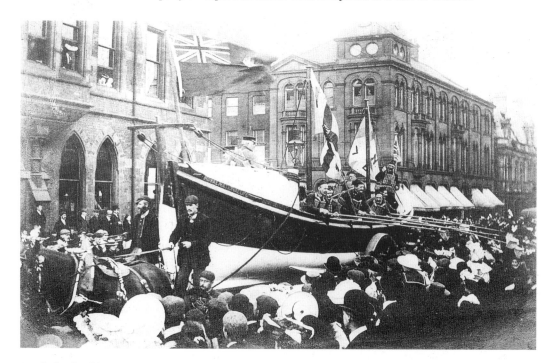

Sunderland Lifeboat Parade, 1904. A lifeboat station was established in 1800 and was taken over by the RNLI in 1865. Owing to problems in finding an adequate site, there were no less than seven different stations at different times. Between 1873 and 1887 there were four at the same time. The motor lifeboat station established in 1912 is now the only one.

2

CENTRAL SUNDERLAND

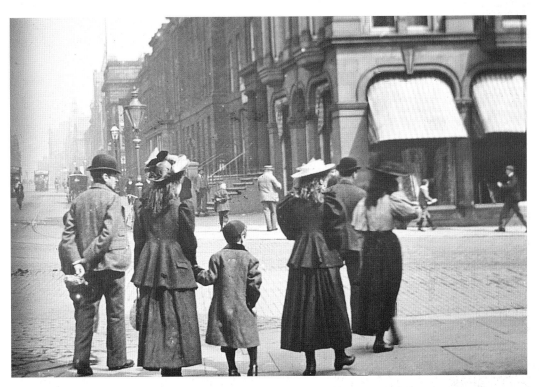

Fawcett Street. The younger women are in ankle-length dresses and one has leg-of-mutton sleeves. A boy is walking unconcernedly in the middle of the road. This must be pre-1901 because there are horse trams. On the corner opposite the Town Hall stood the Athenaeum, which was opened in 1841 and was the home of the Literary and Philosophical Society. The bailiffs were called in 1859 and the Athenaeum then became the Liberal Club. It was fronted by Classical Greek columns which were removed before 1910 because they were an obstruction. The imposing YMCA building was designed by the famous Frank Caws (1845-1905). Caws was not only an imaginative architect, he was also a generous man and much involved in charitable endeavours such as Lambton Street Boys' Club and the YMCA.

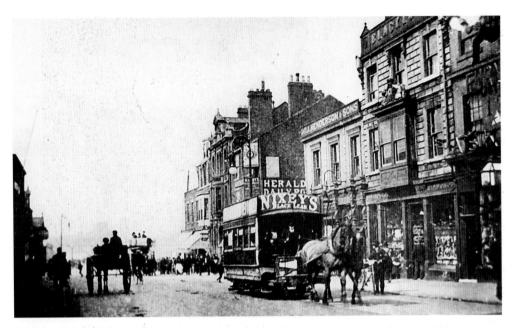

Bridge Street, 1899. From 1879 the Sunderland Tramways Company was running horse-drawn trams – primitive vehicles lit by smoking oil lamps and with floors covered with straw in winter – from Roker under lease from the Sunderland Corporation. The sign on the tram is 'Nixey's Black Lead'. Blacklock's, the pawnbroker and jeweller's, was originally in Bedford Street but moved to Bridge Street and remained there until 1962, when it moved finally to Waterloo Place.

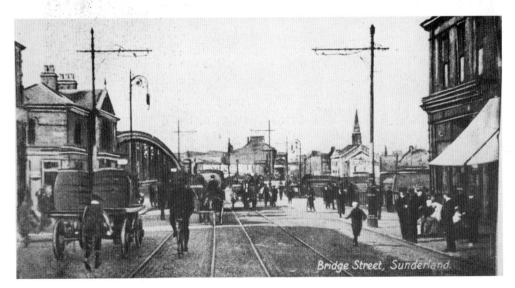

Bridge Street in the 1920s. The Nestle's Milk advert in the middle distance was there for many years. The wagon with the huge barrels may be one of Colonel Prior's beer drays. On the right is a sign for Blacks. The Monkwearmouth Picture Hall, converted from the former St Stephen's Presbyterian Chapel to become the first permanent cinema in the town, was opened in May 1906 by George Black. In 1919 it was taken over by William Marshall and its new name, Bromarsh, was an abbreviated anagram of Marshall Brothers. It was destroyed by enemy bombs in 1943.

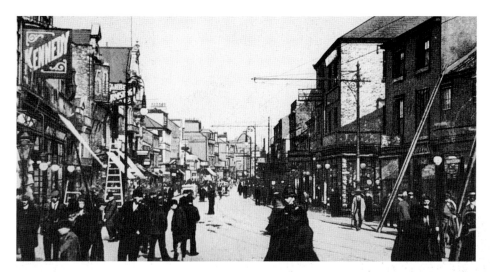

High Street West. This pre-1914 view is towards Mackie's Corner from the west. Kennedy's Department Store, on the left, started at 39 High Street West but extended into the Cobden Exchange Building. It had a system of travelling containers in a chute to carry payment, bills and change between customers and cashiers. Kennedy's even had its own coinage!

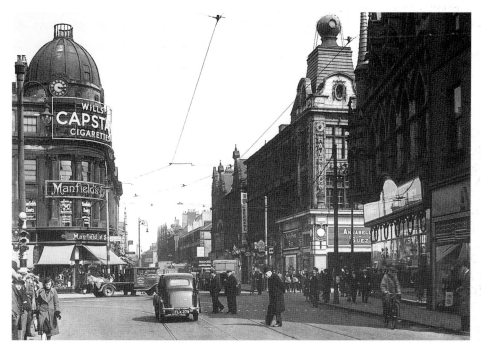

Mackie's Corner, in the late 1940s or early 1950s. Little traffic consciousness here! Three postmen with full bags are about to cross from the Havelock. The scene is dominated by 'Wills Capstan Cigarettes'. Manfield & Sons are advertising boots under 'The Sign of Quality' as 'Worn All Over The World'. The Havelock Theatre, purpose-built as a cinema, was opened in 1915 on the site of Havelock House, which was destroyed by fire in 1898. It was the first cinema in Sunderland to be equipped for sound. It closed in 1963 after a brief period as the Gaumont.

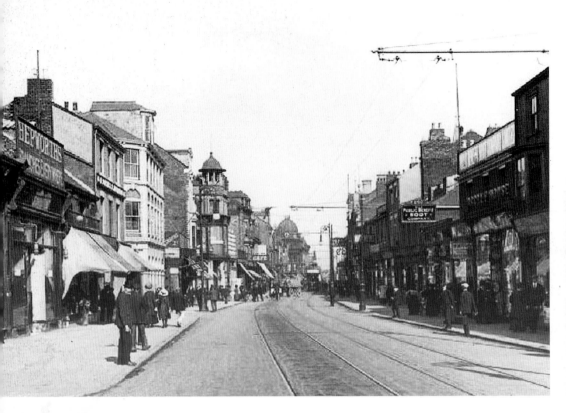

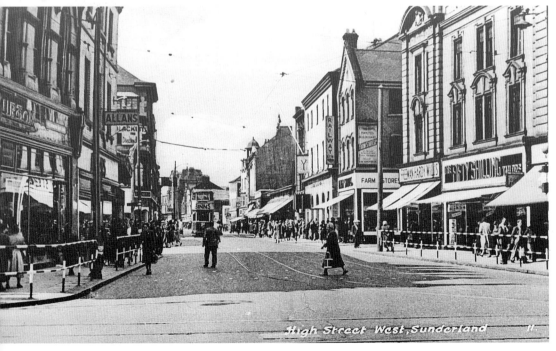

High Street West, Sunderland

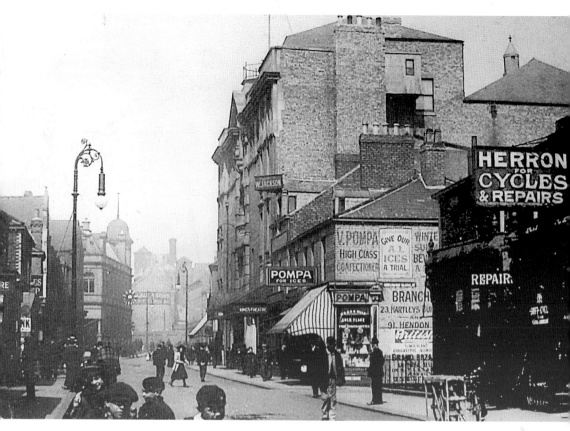

Crowtree Road. A pre-1914 vista of Crowtree Road. On the right is the King's Theatre, described in a pre-1914 newspaper advertisement as a 'charming up-to-date theatre', which opened in 1906. It embodied several modern innovations, such as the cantilever principle to support the circle and gallery areas, and there were new tip-up seats. Unfortunately it was destroyed by bombing in 1943. Also visible is the Londonderry and the Avenue Theatre (which became the Vaux bottling plant); Herrons, which not only supplied bicycles but also made them; V. Pompa, an ice-cream manufacturer with several branches; and Vaux & Sons Brewery, which has a prominent sign. Standing on the pavement in the right-hand corner is the equipment of a knife grinder.

Opposite, above: High Street from the west. Judging from the dresses, this picture must have been taken before 1914. As the town grew, and the Fawcett Street-Bridge Street axis became more significant, the result was the progressive deterioration of High Street and Low Street.

Opposite, below: High Street West from Mackie's Corner, early 1950s. Shops include Burton's, Allan's, the Fifty Shilling Tailors, Freeman, Hardy & Willis, and the Farm Stores. Blackett's was established in 1829 and stocked virtually everything. Particularly notable was a great brass lift in the centre of the store and the chute system which transmitted customers' money to the cashiers and the completed bills and change back to the shop assistant. In 1972 the store closed and in 1978 the premises were demolished.

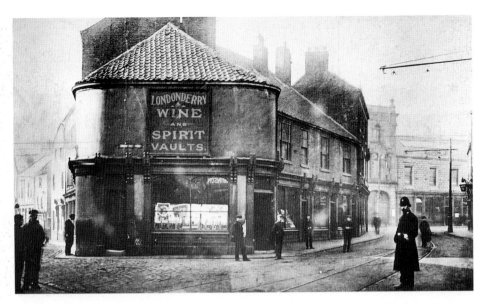

The Londonderry was the Peacock until 1831 and was an important coaching inn and meeting place for Freemasons. It passed to a John Sidgwick in 1853. According to a late nineteenth-century advertisement, his price list sought to '... inform his numerous friends and the public generally that he has on hand a large and well selected stock of wines and spirits, guaranteed unadulterated.'

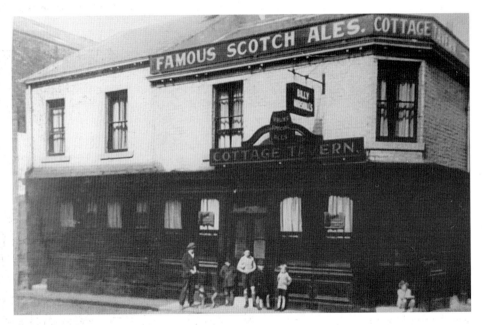

There were no less than four Cottage Taverns in Sunderland – very awkward if one was arranging assignations! There were two in the Hendon area and in the early nineteenth century there was one in Hopper Street. This one in Castle Street was demolished in the 1950s. When it was sold in 1882 it was advertised as follows: 'Bar, Club Room upstairs, yard with Six Stalled stable and the usual out-buildings and is let for £40 per annum.'

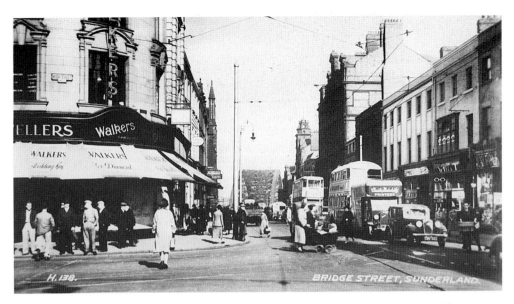

Bridge Street. This looks like the 1940s or later. Walkers, a jeweller's, is on the left. Milburn's bakers are further down and opposite is the Grand Hotel. 'Centrally situated within one minute's walk of the railway station, the "Grand" has an imposing front elevation of five storeys.' This advert in the 1902 Coronation Souvenir also drew attention to the fact that 'The sanitary arrangements are completely in accordance with the latest scientific improvements.' The spectacle adverts of Haig the optician can also be seen. Look at the pram in the centre of the picture! There seem to be two babies in it as well. In the right-hand corner is an errand boy.

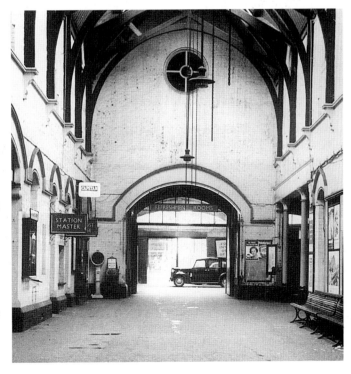

Sunderland station, north end. The old north end of the station is always recalled by Sunderland people as smelling of fish. One of the great entertainments for children for many years was the weighing machine. There was also a gadget with which you could stamp out your name and other details on a metal tag. Simple pleasures!

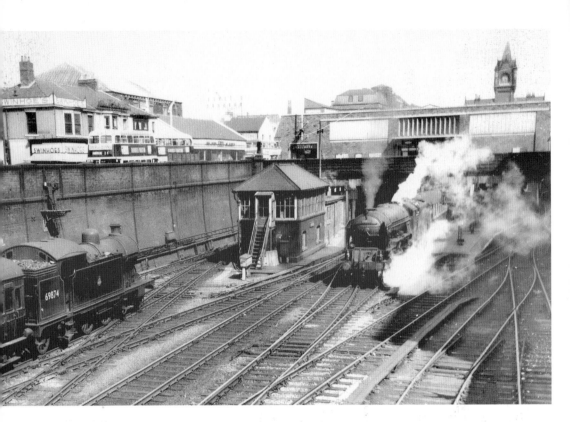

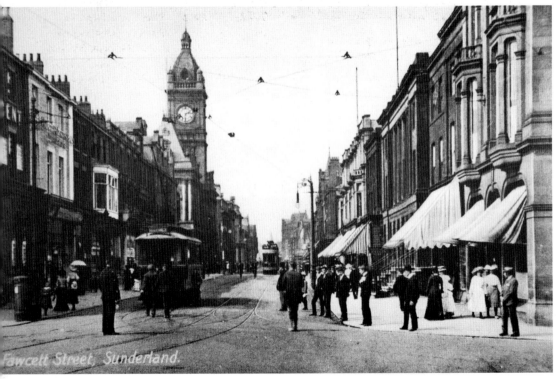

Fawcett Street, Sunderland.

30

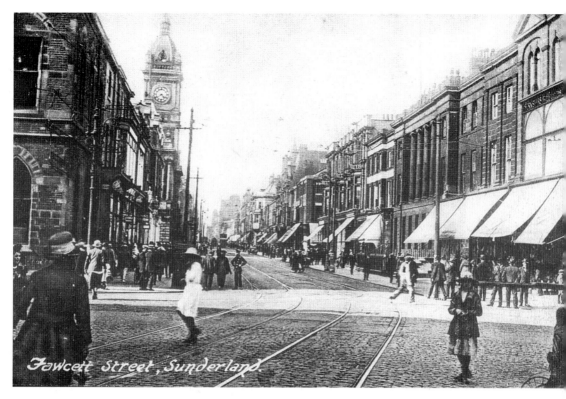

Fawcett Street, Sunderland.

This view is from the Gas Office Corner, post 1918. No-one seems bothered by the traffic. The clock of the Town Hall had a special place in the hearts of Wearsiders. There was a storm of protest at its demise, and the special clock tower promised by the council in compensation was never built. When the Bridges complex was built, the working mechanism of the clock was put on display in a transparent case as if to taunt the passing citizens! The bells could not be used in such a confined space so a synchronised recording of the bells of Durham Cathedral had to be used instead.

Opposite, above: Sunderland Central Station, 1959. William Bell, the architect of the North Eastern Railways, designed the Gothic clock tower and the brick façade of the station on the High Street side, which were built in 1879. The former was a late addition to the design, which arose from denunciation by the local press of a 'contemptible' scheme which would not match the status of the town. *Echo* campaigns on behalf of an 'outraged' public are nothing new!

Opposite, below: Fawcett Street from the north, pre-1914. Originally, C.J. Vincent's premises were in Bridge Street, but he took over those of S.S. Eades at 43 Fawcett Street next to the gas offices. Eventually, Binns took over these premises as well. For many years Gordon Eades' music shop was at 27 Fawcett Street across the road. Binns started as Henry Binns draper's in High Street but moved to Fawcett Street, then began a process of gradually taking over most of the rest of the block south of the railway station. By 1921 it was on both sides of the street and renowned for supplying 'everything that is required for human comfort and welfare.'

31

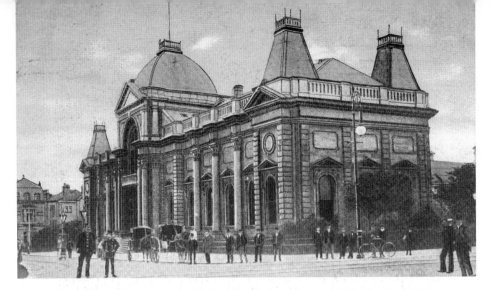

The Central Library and Museum in Borough Road opened in 1879. There was a
subscription library in Sunderland from 1795 and this housed a small subscription
museum from 1810. In 1846 the museum was taken over by the Corporation, then in
1858 it was joined by the public or free library. Initially it was for reference purposes only
and there was no public access to the shelves. In 1879 the grand new library and museum
was opened in Mowbray Park. Although there was still no open access to the shelves until
1911. Until then an indicator board had to be consulted by prospective borrowers. The first
'open access' library in the North East was opened at Hendon in 1908.

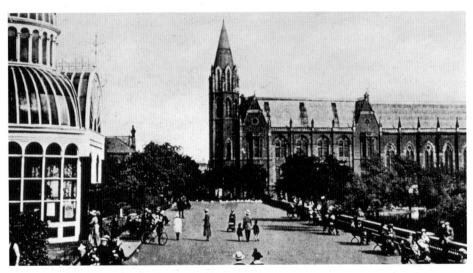

Winter Gardens and the Victoria Hall. The Victoria Hall was the scene of a disaster in 1883
when 183 children died in a stampede down flights of steps at the end of a performance,
eager to claim the free toys and baubles which had been promised in publicity. The country
was shocked and there were floods of donations and condolences. The hall survived but
by the early twentieth century was very dilapidated. In 1903 the Corporation bought it,
modernised and extended it. It reopened in 1906 and in 1941 was destroyed by a German
parachute mine.

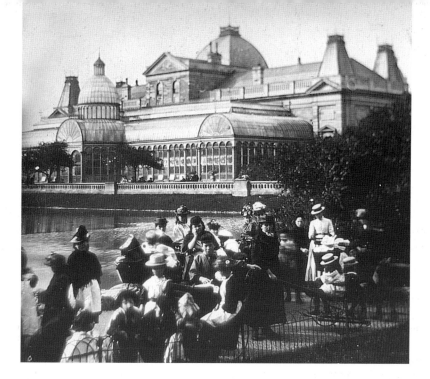

The Winter Gardens and Mowbray Park pond. At the rear of the library and museum was a large conservatory with tropical plants. It was destroyed in 1941 by the impact of the same bomb which damaged the Victoria Hall to such an extent that it had to be demolished. Using National Lottery funding a new Winter Garden, but not the same as the original, has been built.

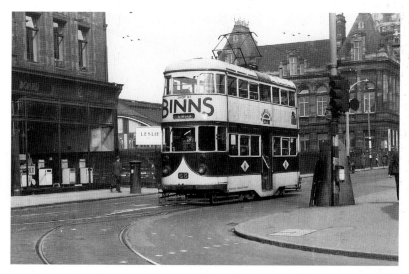

Tramcar 55, Fawcett Street, 1950. Sunderland tram wheels would not rotate on slippery lines, so all trams carried a bag of sand to throw onto the lines and increase the friction. On 3 August 1934 an experimental bus service began on a circle route along the seafront to Whitburn and back to Seaburn. By 1939 the bus fleet was making inroads into the tram routes.

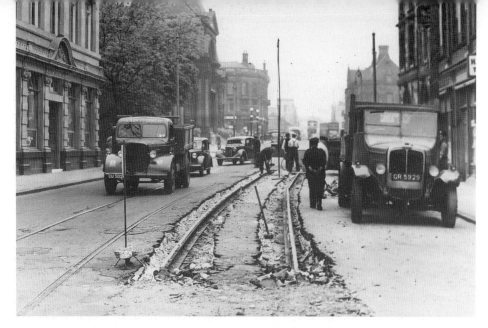

Tram lines being taken up in Borough Road,1952. However, the tramways system continued until 1 October 1954, on which occasion the remaining nine trams were taken out of commission amidst pomp and circumstance. No. 86 was the last tram officially to run in Sunderland.

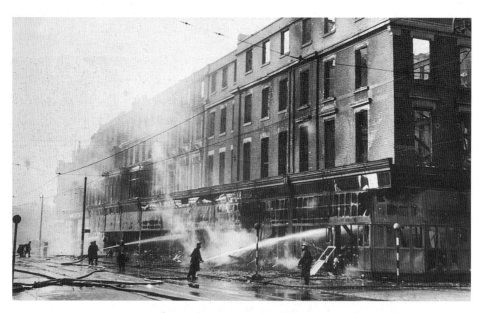

In April 1941 the Fawcett Street premises of Binns were destroyed by fire following a bombing raid. The store was soon operating again from premises in Holmeside. A new building on the west side of Fawcett Street opened in 1953 and on the east side in 1962. Eventually there was also an underground connecting passage beneath the road. The new Binns was notable for its restaurants, which included the Bear Pit and the Gay Tray! Binns finally closed in 1992 and the west side premises were taken over by Central Stores and then Wilkinson's.

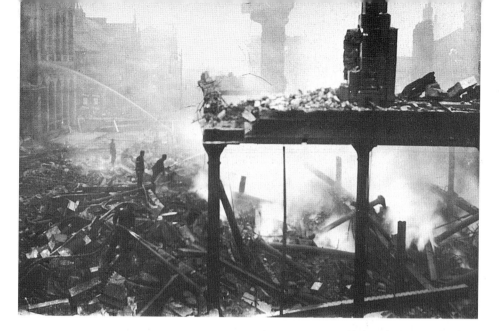

Havelock House began in High Street East but moved in the 1880s to Fawcett Street. It was famous for fashionable ladies' clothing and its dress and costume-making business. The Havelock building burnt down in 1898 together with other properties in the area. At that time Sunderland relied on a series of fire hydrants. The water pressure was low so the River Wear police and LNER brought their hosepipes to get water from the river to fight the fire. The store was rebuilt and in 1915 this became the site of the Havelock cinema.

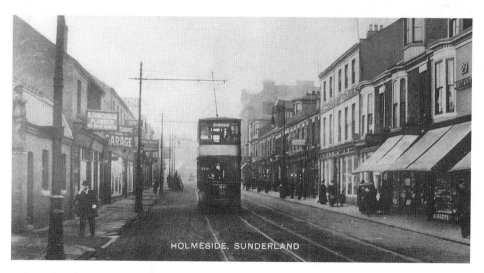

HOLMESIDE, SUNDERLAND

Holmeside. This pre-1914 view is looking towards Vine Place. A circle tram is gliding quietly towards the camera. On the left is Fairclough's the plumber and Turvey's Garage. Also visible is Laidler, Robsons & Co. who 'are pleased to undertake the Complete Decoration and Furnishing of Rooms, Houses etc. The Advantage of placing the Entire Scheme in the hands of one competent firm cannot be overestimated, assuring as it does a perfectly harmonious tout ensemble, and materially, minimising the cost. Estimates, Designs and Suggestions Gratis.' On the corner was Maynards Ltd, Toffee Makers.

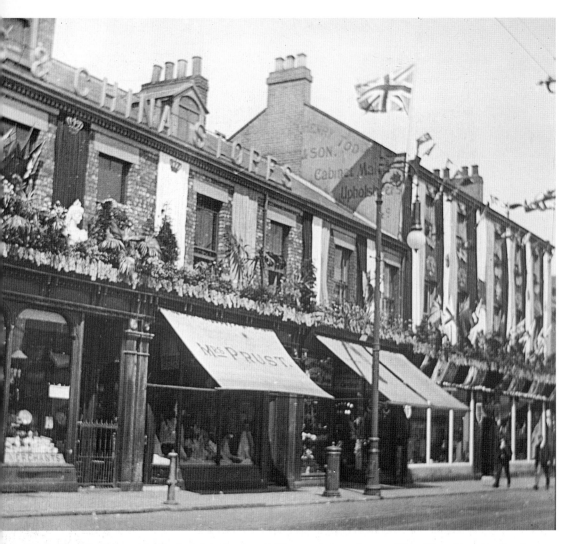

Mrs Prust's, Holmeside. On its left is the finest china and glass shop on Wearside – Townsend's at 22 Holmeside. They were the sole agents for Crown, Derby, Royal Worcester and Coalport china and also stocked a variety of products from other suppliers. To the right of Mrs Prust's the roof advert is for Henry Tod & Son, cabinet makers and upholsterers. The display of crowns and a bust of Queen Alexandra suggest that this is 1901 – the coronation of Edward VII.

Opposite, above: Littlegate Bishopwearmouth, near Bishopwearmouth Green, 1920. The signs are for F. Trewhitt RSS – Cartwright, Horse Shoer and General Smith. Next to it is the Victoria Cart and Rolley Works.

Opposite, below: Tramcar 53, Chester Road, 1953. This picture was taken near the old railway bridge, over which crossed what was originally the old Newbottle Wagonway on its way to the riverside. Kemps is on the right. There is still a Kemps today further up Chester Road supplying babywear.

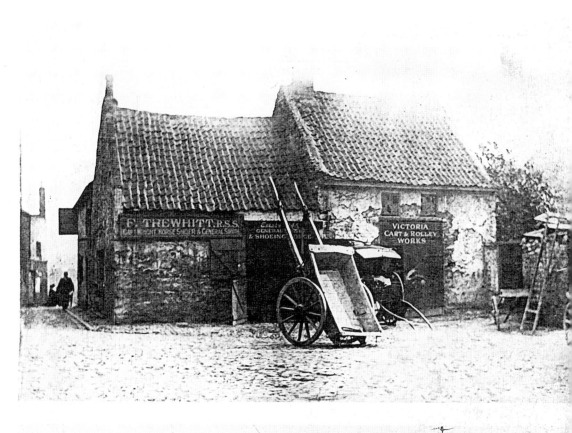

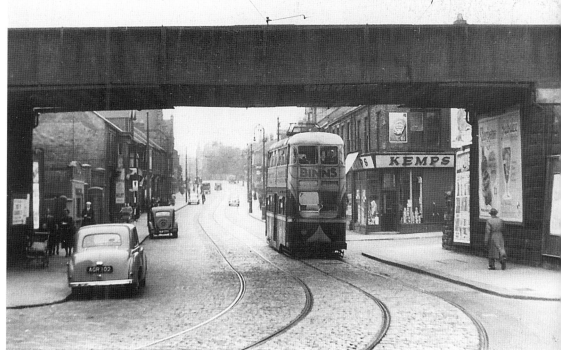

37

Chester Road. It can't have been much fun riding a bike on those cobbles.

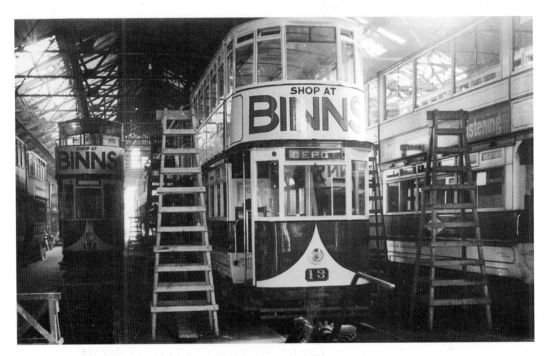

Tramcar 13 at Hylton Road Depot, 1950. This depot was opened in 1903 and held fifty trams, a paint shop and a blacksmith's. It was later used for building Sunderland's own trams, and eventually became a bus depot. A depot was acquired at the Wheatsheaf when the Corporation took over the Tramways Company in 1900. It was reconstructed from stables to hold another fifty trams. A purpose-built depot was opened in 1905 with facilities such as a staff canteen, pits for access to underneath the trams and cash cabins where the staff could total their daily takings. The administrative offices were next to the Town Hall in Fawcett Street until a new office block was built in 1967.

3

EAST END, HENDON AND GRANGETOWN

Drury Lane, 1935. Drury Lane derived its name from the theatre which was established there in a disused chapel in the narrow street leading off High Street. In the mid-nineteenth century it became the Wear Music Hall.

Church Street, looking towards the river. The buildings are numbered on the picture for some reason. Numbers 10 and 11 are now the Hearts of Oak public house. They are some of the oldest buildings in Sunderland, dating back to the early eighteenth century, and were once the fine houses of wealthy merchants. Eventually the wealthier sections of the community moved away from the East End and many big houses like these became subdivided into overcrowded slums.

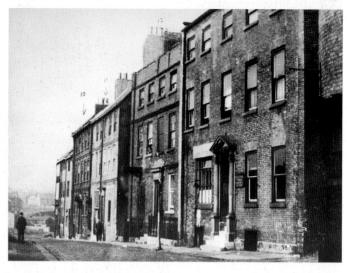

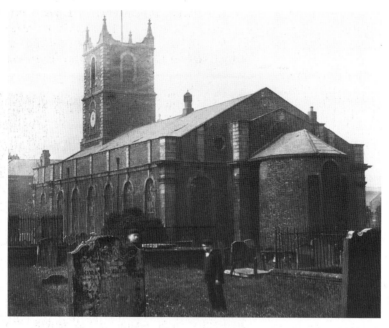

Holy Trinity Church, consecrated in 1719. It was built to cater for the growing population of the newly created parish of Sunderland in recognition of the growing significance of the mercantile heart of the community. In its day it was one of the largest brick buildings in northern England. It also acted as a sort of town hall for Sunderland. Parish activities were managed from the vestry room by twenty-four vestrymen under the rector as chairman. The remaining few gravestones include the grave of Jack Crawford, the 'hero of Camperdown', and an early victim of cholera. The boys look a little suspicious . . .

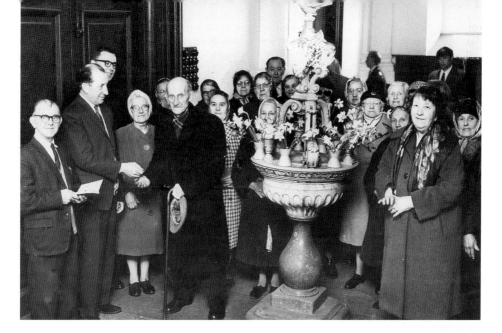

Dame Dorothy's Dole Ceremony. The old Easter Monday ceremony of Dame Dorothy's Dole is superintended here in 1970 by Michael White and the churchwardens Messrs Prince and Reay. Robert Prince was a general foreman joiner for J. & T. Parkers local builders in Commercial Road opposite Brian Mills. He was related to the Reays, who looked after the Donnison School. One of the Reays was the famous hot potato man, a local character who had a regular site in Bedford Street.

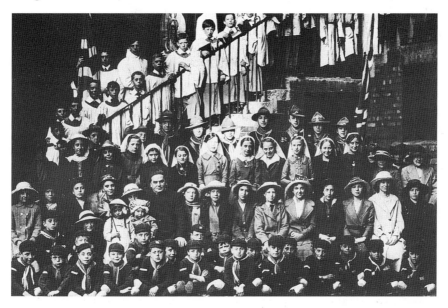

This is a collective photograph of groups associated with St John's Church. There are scouts and leaders at the back; cub scouts (or wolf cubs more properly) at the front; the choir; rows of women and girls and the vicar in the middle. St John's was consecrated in 1769 and was in a style similar to Holy Trinity. It held up to 1,400 people and the ranks were swelled by the fact that the barracks were close by. It was demolished in the 1970s.

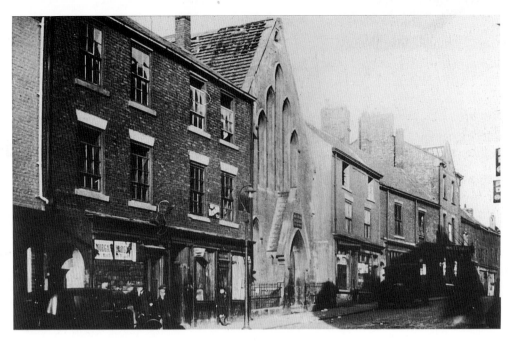

Wesleyan chapel, Yuill's Passage, 1933. The Boars Head is on the far left. Once this was typical of the narrow alleys and lanes of the East End, but the Deep Water Quay was created here and all of these buildings were demolished.

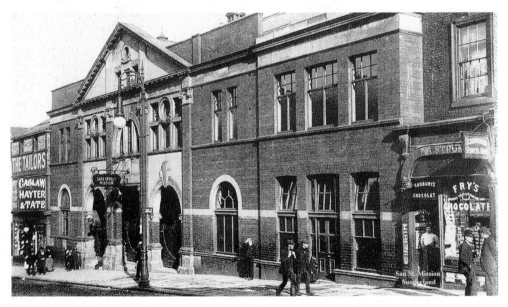

Sans Street Mission, which held up to 2,500 people. To the left is Caslaw, Hayter & Tate the tailor's, who supplied Merchant Navy and other uniforms. However, for parents they were notable for the supply of school uniforms. On the right is a sweet shop with Fry's Chocolate prominently advertised.

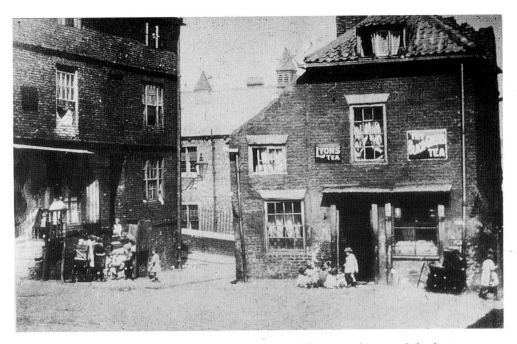

Numbers Garth – one of the poorest streets in the East End. It was also one of the first areas where John Wesley preached during one of his many visits to the town. The building on the right is a corner street shop judging from the adverts.

Fitters Row, 1873. In the closed courts and narrow alleys of old Sunderland were slum conditions comparable to those in other major industrial cities. By the 1850s houses in the parish held on average nine or ten inhabitants. Less than 7 per cent had their own privies and the Fitters Row area was typical. The once elegant houses here had been built for wealthy coal fitters, but by 1873 it was an area of desperate human degradation.

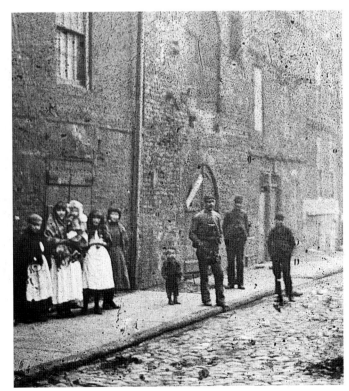

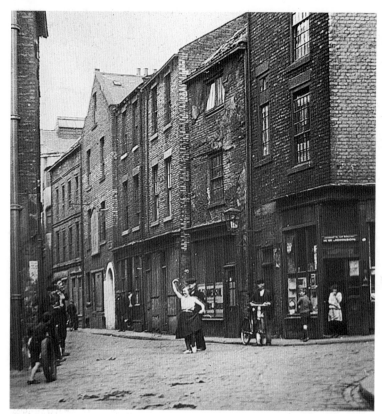

East End acrobatics
in Union Street or
Villiers Street, 1920s.
It is not at all clear
what the story is
behind this apparently
impromptu balletic
performance, which is
captured by a passing
photographer.

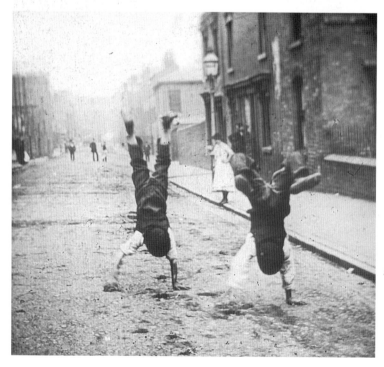

East End Street.
It seems that the
woman behind
the two children
performing
handstands is actually
timing them. She
seems to be looking
at, perhaps, a watch
in her hand.

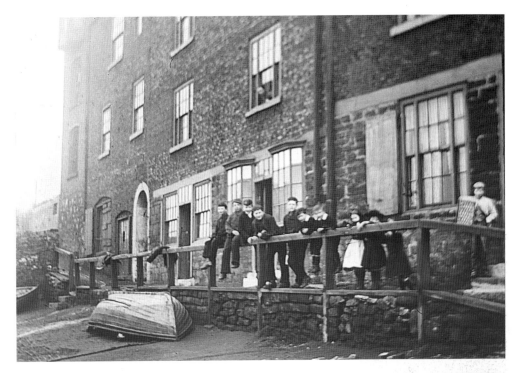

A riverside group, *c.* 1900.
This looks like Low Street.

No. 33 Low Street, Drysdale.
In the eighteenth century
Low Street was a busy and
prosperous part of the town;
there were shops dealing in
furs and jewellery as well as
ships chandlers and other
mercantile suppliers. By the
time this picture was taken
though it has declined very
much in status because of the
changing commercial axis of
the town. The photographer is
being watched by a face in an
upper window.

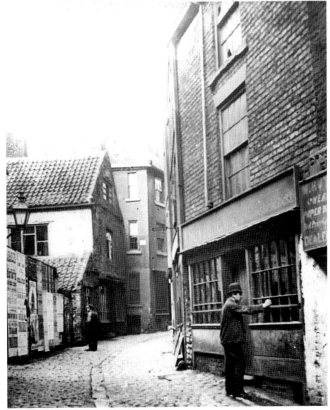

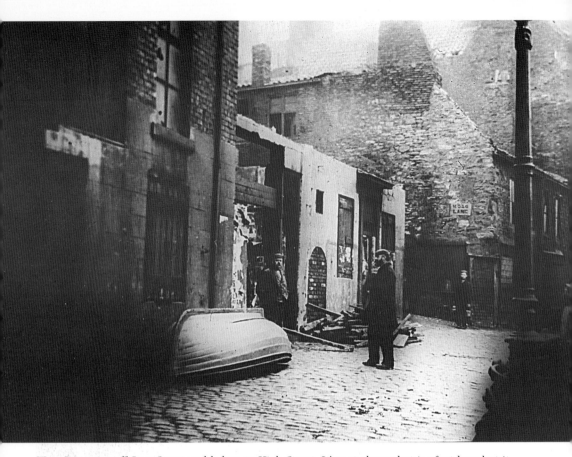

Moss Lane was off Low Street and led up to High Street. It's not clear what is afoot here but it gives an impression of the decay of the area by the twentieth century.

Opposite, above: East End carnival, 1928. It looks as though the man and woman have been crowned for the carnival, although the year 1928 has no significance as far as the royal family are concerned. The carnival was a popular occasion; at carnival time there would be a fairground, which covered all the town moor. The whole community got together; also, it gave the unemployed something to do, to make the carnival work. Each street had its own street party and all the exteriors of the houses were decorated. It gave the people in the area an identity and pride in what they could produce.

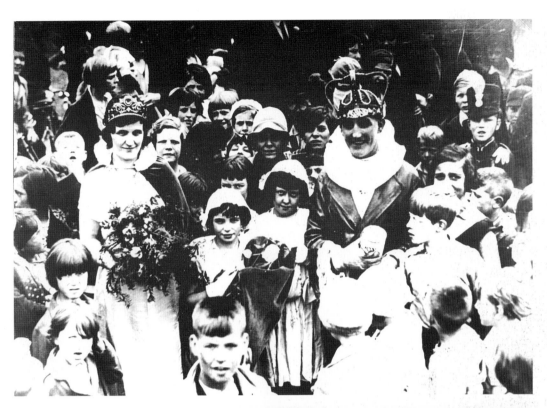

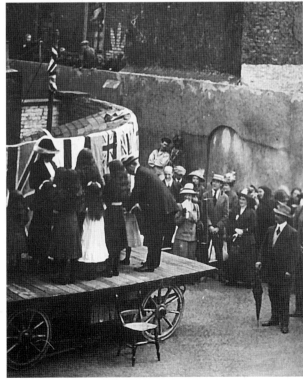

Longest Hair competition. This
is an Edwardian picture judging
from the dresses and the straw
'skimmers'.

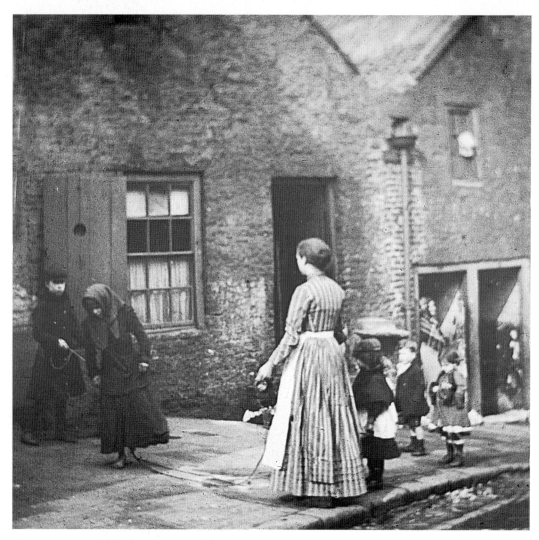

Skipping in Low Bank, 1910; a good photograph of a common street scene. Children played in the streets for hours: 'Sum o' the games I remember are ones we played in the street because there wasn't much room inside the 'ouse ... We had loads of fun playin' out all hours; tops and whips; marbles; jumpy-on-back; mounty kitty; Jack-shine-the-Maggy; in and out those dusty bluebells; I wrote a letter to my love and on the way I lost it; Bobby bingo; hide-and-seek; duck stone; kick the can; bowling hoops; knocky nine doors; tally ho; hitchy coit; French cricket; rounders.' (Mr Johnson)

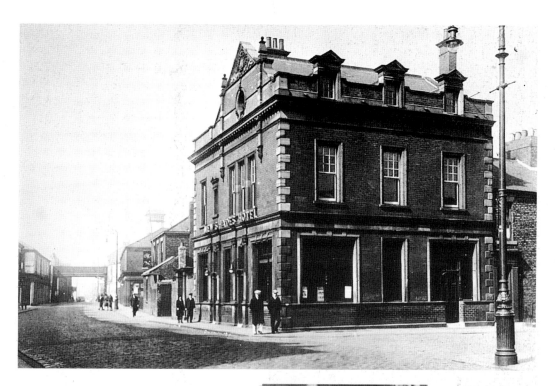

The New Shades Hotel in Hendon
Road; the original Shades Inn stood
in High Street East. In 1889 it was
bought for £3,000 by James Chrisp,
former butler of James Hartley. Chrisp
built up a small empire of licensed
premises in Sunderland and also became
a councillor. However, he gained a
bad reputation after an assault on a
complaining customer in the Shades
and the resultant court case. The
Shades itself acquired a bad reputation
for disorderliness. Interestingly, 'the
shades' is another name for the home
of the dead or Hades – it may well have
been the name of a ship originally, but
even then it would seem an unlikely
choice!

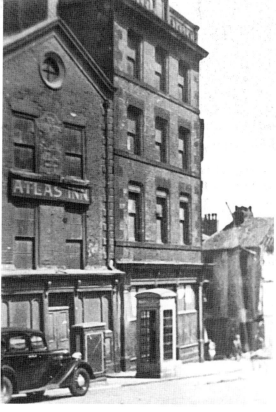

The Atlas: probably the one which
stood in High Street East and belonged
to James Chrisp. This, his first pub
venture, he recalled as 'worth a guinea
a brick' to him.

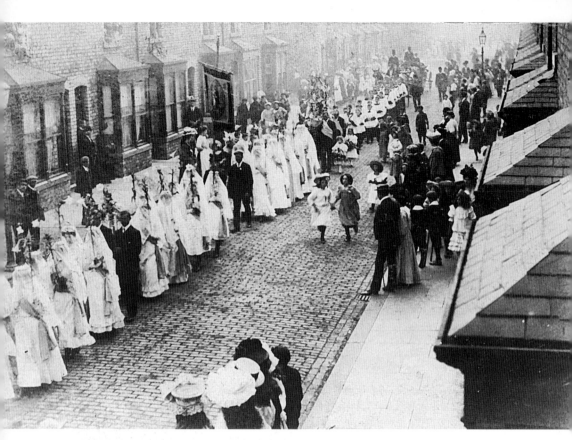

This is allegedly Villette Road but may in fact be Chester Road (square bays are not a feature of Villette Road). This could be a May Day event or something similar.

4

BESIDE THE SEASIDE: FULWELL, ROKER AND SEABURN

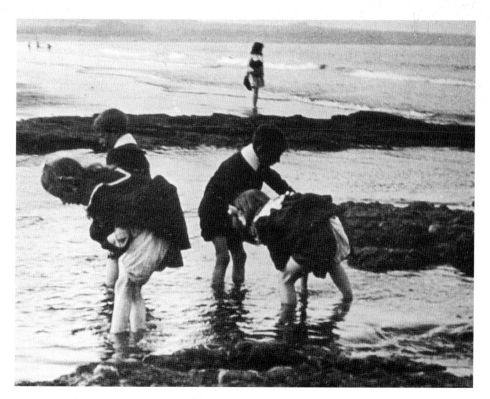

This looks like Hendon Beach; it doesn't matter though because it could be anywhere. This will be the early twentieth century, perhaps just pre-war.

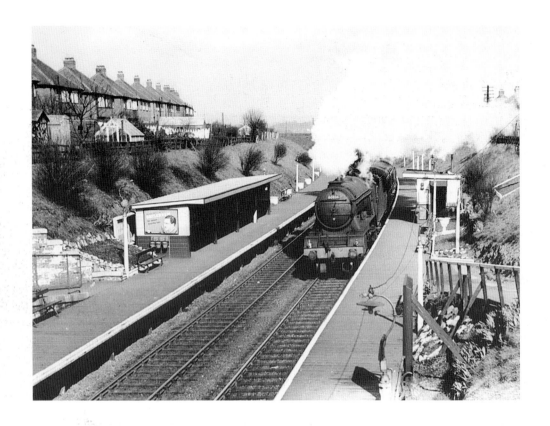

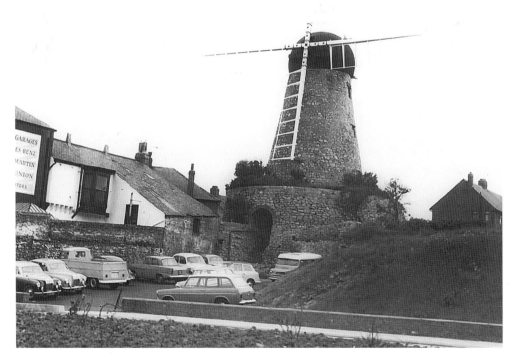

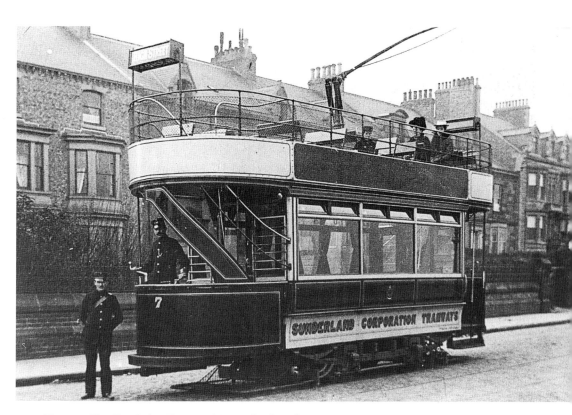

Tramcar No. 7 at Roker Terrace, 1900. The first electric tramway route connected Roker and Fulwell with the town centre. This is one of the first trams in Sunderland.

Opposite, above: Seaburn station, 1962. Brylcream is being advertised. Of course the station is on the main East Coast line. Many people of 'a certain age' will remember using the train for local journeys to Boldon Flats with fishing nets and jam jars and catching vast numbers of 'taddies'. At least it kept down the frog population.

Opposite, below: Fulwell Mill, 1962. This prominent landmark, built in 1821, has been restored to full working order. It is the most complete mill standing between Humberside and the Firth of Forth. The sails were replaced in 1986 and the mill was reopened to the public in 1991. It is made of magnesian limestone, which is predominant in this area.

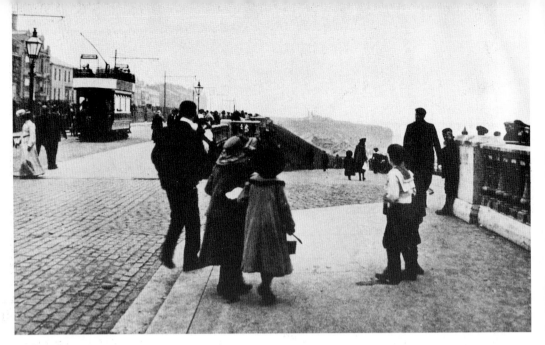

The Terrace, Roker, pre-First World War. Electric trams have arrived. This picture is taken from beside the famous Bungalow Café which is still open for business. Plans to demolish it came to nought in the 1980s.

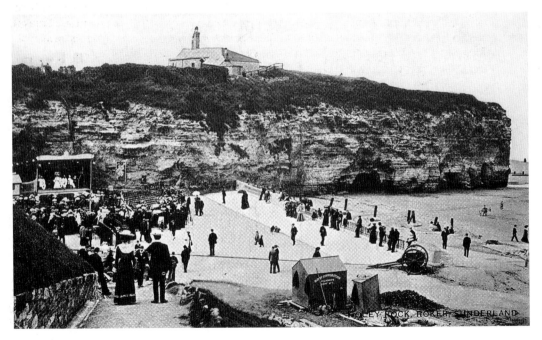

Holey Rock, Roker, 1906. On stage to the left are 'The Jumbles'; such itinerant pierrot groups were popular performers at seaside resorts. Behind them, the Holey Rock was so-called simply because it was riddled with holes – it had no religious significance. The caves were an adventure playground for young children, but also for rather more focused gamblers. The men of the Sunderland Corporation Highways Department have dug up part of the road – seeing as it's the holiday season!

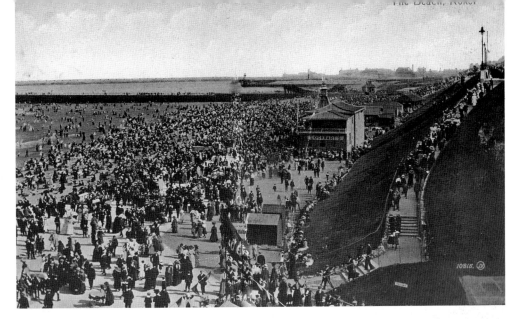

Roker Beach. The long dresses indicate that this is pre-First World War. The pier ends cannot be seen but the South Pier, or Breakwater, is well advanced, meaning that this is likely to be in the 1910 period. Lockhart's on the right is one of a chain of restaurants – Lockhart's Cafés. These were cocoa rooms and were a nation-wide phenomenon. Charles Booth explains very well what their nature and intention was: 'Cocoa Rooms, and especially Lockhart's cocoa rooms, have become an important factor in the life of the people ... In their rules they are wisely liberal: those who drink the cocoa may sit at the tables to eat the dinner or breakfast they have brought from home, or bringing the bread and butter from home they can add the sausage or whatever completes the meal.' (Charles Booth, *Life and Labour of the People in London*, 1903)

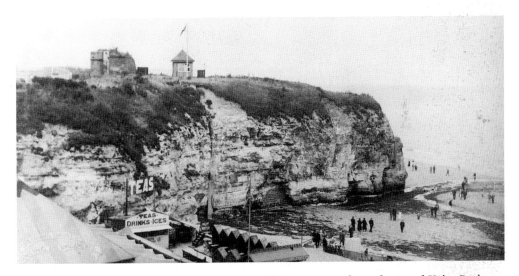

Holey Rock, Roker, probably in the early 1920s. Abbs Battery stands on the top of Holey Rock and on the left is the Holey Rock Dance and Tea Gardens, which opened in 1922. On the roof it says 'Eats - Drinks - Smokes - Dancing - Amusements' then beneath that 'Under Ideal Conditions'. There is also the 'Picnickers' Headquarters' with drinks and ices. Alternatively one could just buy hot water and do-it-yourself. Some of the holes in Holey Rock have been bricked up.

55

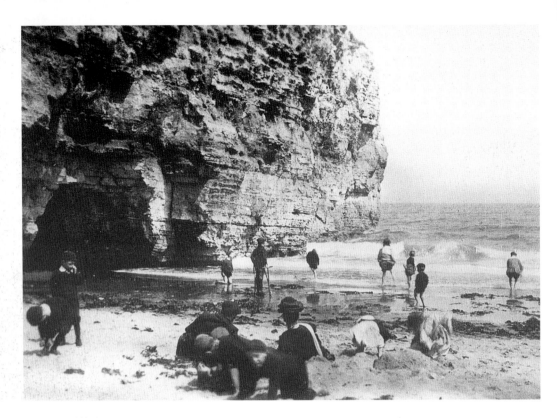

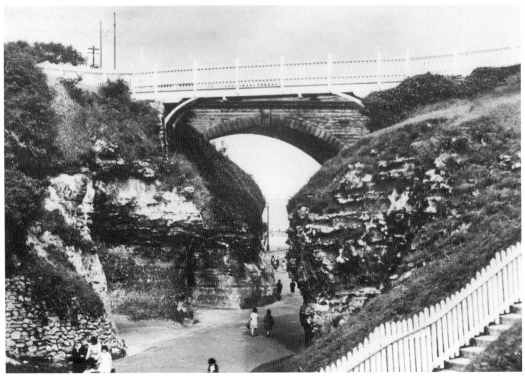

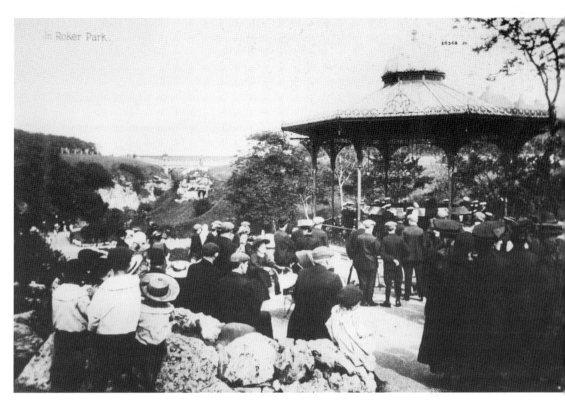

Roker Park, bandstand. This looks pre-First World War. The *Sunderland Year Book of 1905* remarked of Roker that 'of the many changes that have been effected, none have been more appreciated than the erection of the handsome new bandstand. It is something more than ornamental for it has proved a real utility.'

Opposite, above: Holey Rock, Roker. The boys are doing what boys have done here for generations: getting wet and filthy. In 1930 it was decided that the honeycomb of holes and caves, together with the loose rocks falling from it and small boys climbing it, was a recipe for accidents. Originally the plan was to fill the caves with concrete. Work on building a new retaining wall began in 1936; this eventually extended round Roker Beach and the main Holey Rock was demolished. From the front the Rock resembled an elephant which is why it was also known as Elephant Rock.

Opposite, below: These are the two bridges over the Roker Park Ravine, seen here in the 1940s or '50s. The pedestrian bridge, built in 1901, was the first example of a creosote-impregnated bridge. The ravine was, for a long time, an obstacle to the development of the seafront. The donor of the land on which the park was laid out in 1880 was Sir Hedworth Williamson of Whitburn Hall and the donation was made on condition that a bridge should be built over the ravine. The Roker Ravine area with its numerous caves and clefts was, apparently, a smugglers' haunt (and certainly used for illicit pontoon games in more modern times).

ROKER SANDS. SUNDERLAND.

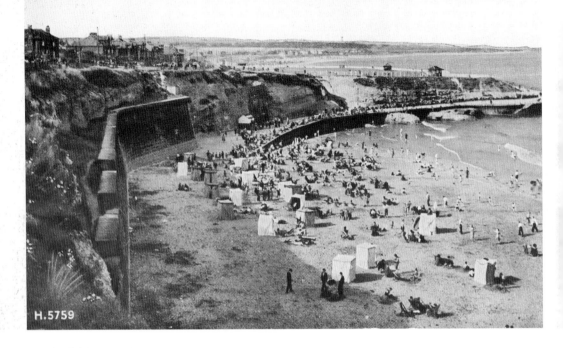

H.5759

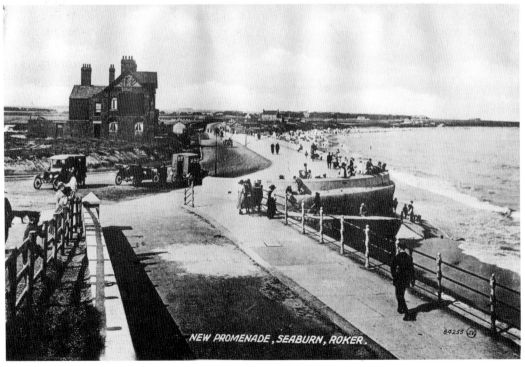

NEW PROMENADE, SEABURN, ROKER.

84255

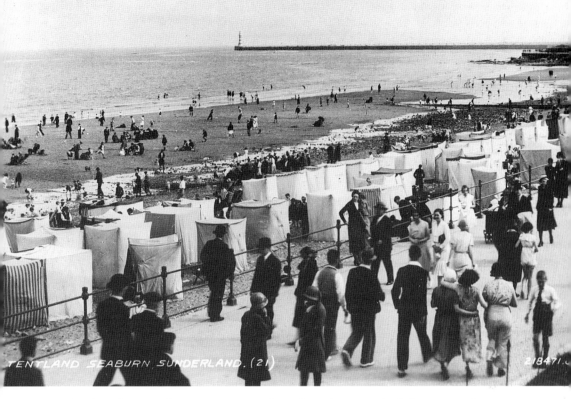

TENTLAND SEABURN SUNDERLAND. (21) 218471.

Tentland, Seaburn, in the 1920s or '30s judging from the women's clothing. Since the tents were usually in fairly standard colours – light green or off-white – they could not be easily distinguished apart. For small children emerging from the sea it was easy to lose track of their home tent. In the case of small boys the situation was worsened by having to hang on to waterlogged knitted swimming trunks at the same time. The Lost Children Kiosk was a busy place as frantic parents were reunited with tear-stained sandy offspring.

Opposite, above: Roker Sands; this must be pre-Second World War. The Cat and Dog Steps was the name which developed for the section of promenade here. It is still a popular area for sun-worshippers. The promenade was a scheme for the unemployed after the First World War and involved the destruction or covering of a substantial section of the rare Cannonball Rock feature (which appears in only two or three other areas in the world). However, there is still a large mass of it here and more sections further along.

Opposite, below: The New Promenade, Seaburn; this looks like the early 1920s as the seafront has still not been developed. The Seaburn Hotel and small seafront shopping complex have not yet been built. In 1936 an improvement scheme was approved and the result was the building of a wide range of beach and park amenities for day-trippers and holidaymakers, as well as the Seaburn Hotel and Seaburn Hall.

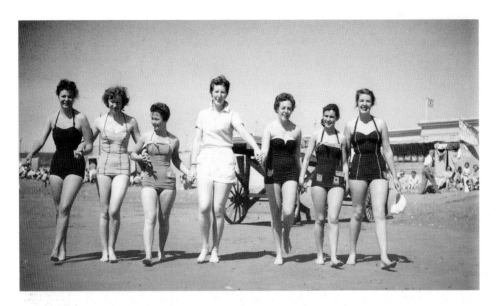

Bathing beauties at Seaburn, 1957. Perhaps it is a church outing: the sign on the right says 'St John's Prudhoe'. At this time Sunderland was still a popular destination for beach lovers from the region. However, the arrival of the cheap package holidays to Spain and elsewhere would signal the end of the British seaside holiday trade.

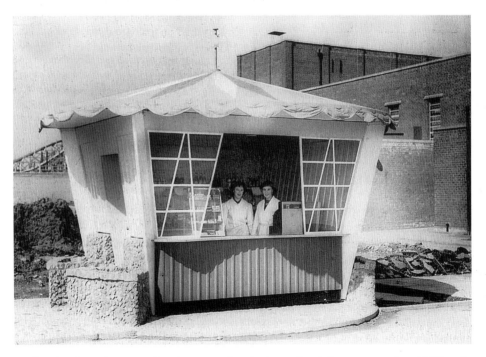

Trading kiosk, Seaburn, 1955. The series of eight 'super kiosks' were opened in 1955 and formed part of the Seaburn development scheme. One of them sold candyfloss, another sold toffee apples (but not spare teeth) and another sold 'willicks' or winkles at sixpence or a 'tanner' a bag – the pin was free.

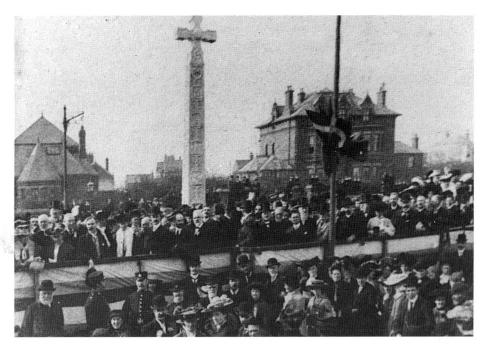

The Bede Memorial was unveiled in 1904 by the Archbishop of York before an audience of 5,000 people. During the First World War it was removed for safety then placed after the war in its present position in Cliff Park. Another war, another relocation in 1939 – this time to Eden Vale Corporation Yard. It was re-erected in 1949.

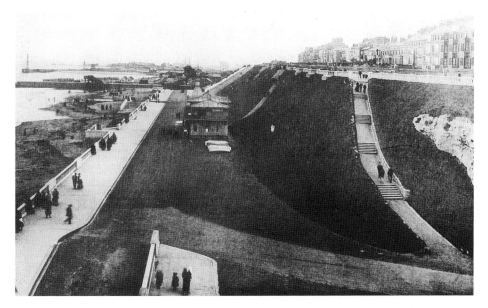

Roker, pre-1914. The lower promenade was started in 1886 as part of the Roker Improvement Works programme to create jobs in years of depression. The Corporation got permission from the local government board to raise a loan of £7,000. The pay was 2s 6d a day and work was interrupted frequently by bad weather – but the alternative was the workhouse.

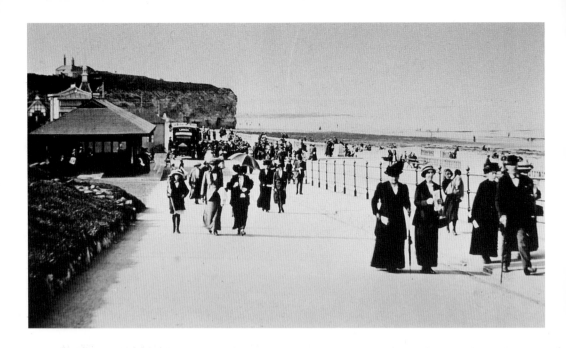

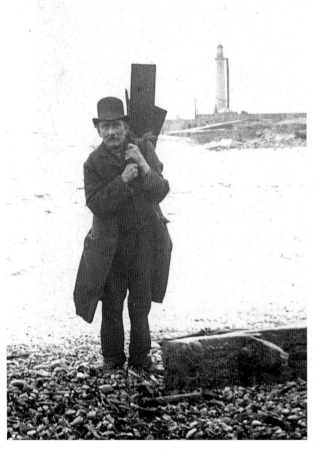

Victorians at Roker, 1900. The older women in the picture have long dresses but the young girls wear knee-length. The sign on the truck says 'Canada'. One woman is using her umbrella as a parasol.

This man is gathering timber on what used to be known as the Bathing Beach – the beach between the Roker Pier and the old inner North Pier. It looks as if the lighthouse on the North Pier might be being removed so this photo must have been taken around 1902.

5

COLLIERY COMMUNITIES

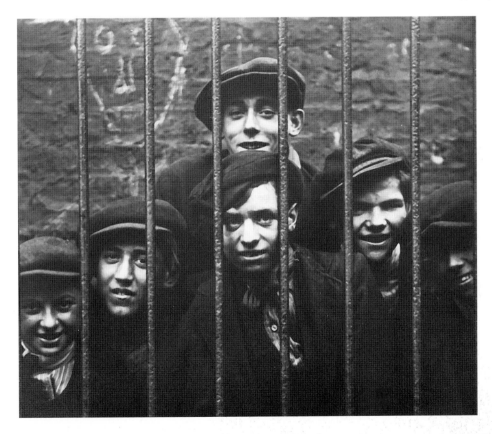

Five boys from Ryhope or Silksworth Colliery. The chalk drawing on the back wall could be of the deputy or overman. It certainly isn't very flattering.

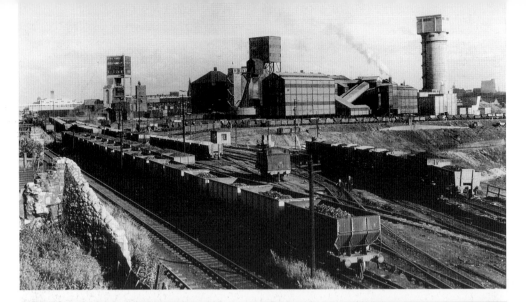

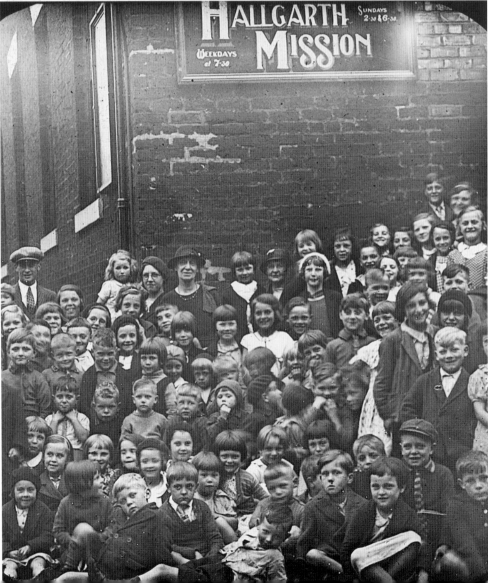

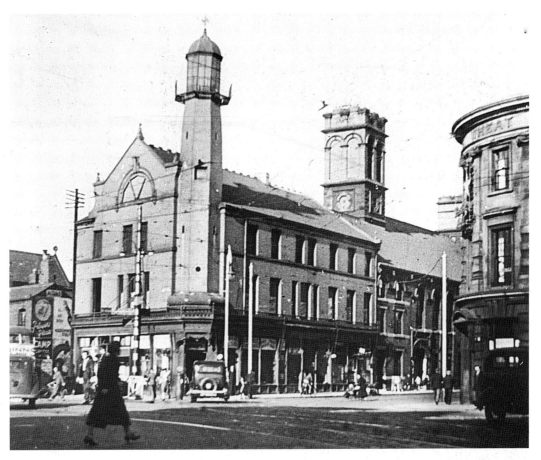

Wheatsheaf, 1940s. The Lighthouse building was originally occupied by Wills' Lighthouse Stores, wholesale and retail grocer's. At various other times it was occupied by Chappell Brothers, a butcher's supply business, and Walter Willson's grocers. However, it is probably most memorable for the sweetshop J.C. Marlee, the final occupant. The superstructure was a wooden model of the famous Pickernel lighthouse. There was a light in this replica but it was not allowed to be used because it could be misinterpreted from the sea as a genuine navigation light and vessels might have strayed up Roker Avenue!

Opposite, above: Wearmouth Colliery and Sidings, 1960s. The Wearmouth Colliery was sunk between 1826 and 1834, however it was not until 1835 that the first shipments were made from what was then the deepest pit in the world. By 1857 it employed 1,200 men and boys and produced 500,000 tons of coal annually. This area is now the site of the Stadium of Light.

Opposite, below: Hallgarth Mission (Presbyterian). Hallgarth was the area around St Peter's Church; it was very poor and had some of the worst slums in the town. The Monkwearmouth Shore area was known as the Barbary Coast: 'I often reminisce about the old days and that area of Monkwearmouth Riverside known throughout my lifetime and before as "The Barbary Coast". Hedworth Street and others were mainly tenements and led down to the Ferry and Folly End. Often four families to a house, a large family of six children meant eight people sharing the one bedroom. Today it sounds terrible, but that was the way it was.'

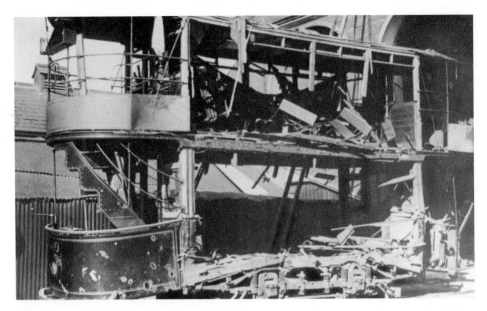

Tramcar No. 10 at the Wheatsheaf, 1 April 1916. The zeppelin bomb was dropped on the doorstep of the Wheatsheaf Tramway Office; this was a direct hit. The conductor was a woman, Margaret Ann Holmes. During the raid twenty-two people died and 105 people were injured. A Tramways inspector died in the incident. Margaret Holmes was badly injured but recovered and lived until 1986, when she died aged ninety-one.

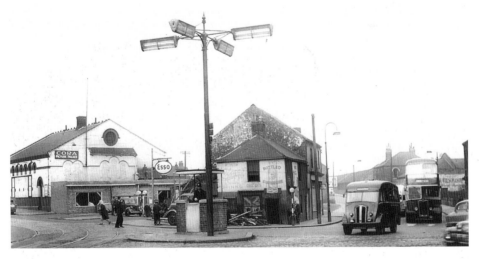

Wheatsheaf Junction, 1950s. The policeman is directing the traffic within his box at a busy junction; there is an Esso garage behind him. To the right is Cleggs which appears to be being demolished. It sold, amongst other things, 'Bottled Sunshine' as well as drinks and choc ices. Windows are broken and there is a heap of salvaged timbers near the door. The Cora Picture Palace had been the Wheatsheaf Picture Hall and started to show moving pictures in 1907. In 1911 it became the Coronation Picture Palace. The second smallest cinema in Sunderland, it was known as a 'flea pit' – it certainly had to be disinfected by the council in 1930. It closed in 1959 but was not demolished until 1982.

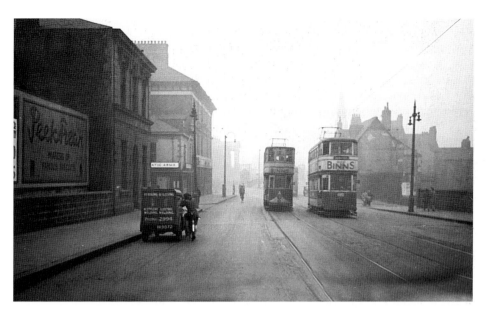

North Bridge Street, 1950s. The van on the left advertises Acetylene and Electric Welding; the owner's name is not clear. There is a woman on a bicycle alongside and rapt in discussion with the driver. Three trams drift quietly towards the Wearmouth Bridge, emblazoned with the obligatory 'Shop at Binns'. Along the west side of North Bridge Street are the Aquatic Arms and the pillars of Monkwearmouth station. The former, demolished in 1973, was popular with rag-and-bone men or 'tatters' who had their stables in the nearby Sheepfolds area.

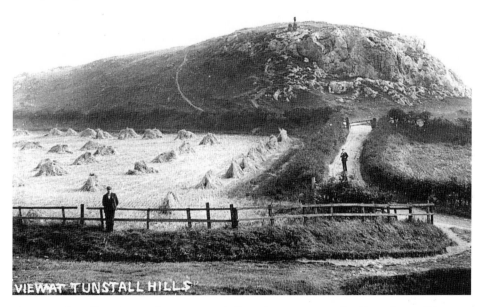

VIEW AT TUNSTALL HILLS

This is Rocky Hill in 1910. There are two hills making up Tunstall Hills with a saddle between them. In fact the hills, which dominate the horizon between Ryhope and Sunderland, are the remains of very ancient coral reefs. Locally Tunstall Hills were known, for obvious reasons, as the Maiden's Paps. These fields may belong to Elstob Farm.

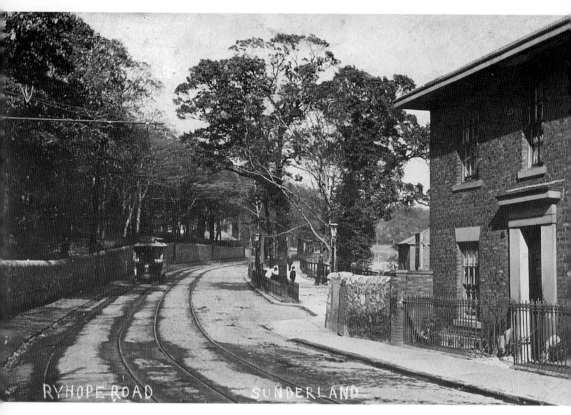

Ryhope Road, 1905. The Corporation electric tram system was cheap. Between 1900 and 1948 passengers could travel to any part of the system for 1*d*. You had to sit on wooden benches though! The downstairs compartment was reserved for non-smokers, while the wheezers and coughers could make their way upstairs. The Corporation only had a dozen single deck tramcars and it used them because they were the only cars which could get under the bridge at Tatham Street.

Opposite, above: Ryhope Road, 1888 – an unusual snow scene picture. The cart may be a coal cart. Backhouse Park is on the right.

Opposite, below: Silksworth Hall from the north-west, 1903. The main building still stands in the village centre. It was occupied by different families at various times, such as the Beckwiths and Robinsons. More recently it was a hotel; at the time of writing it is not in use.

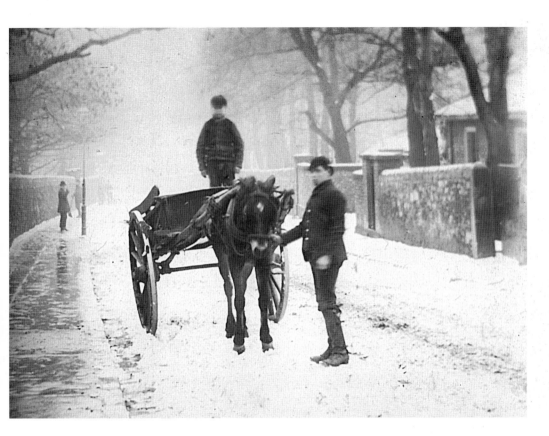

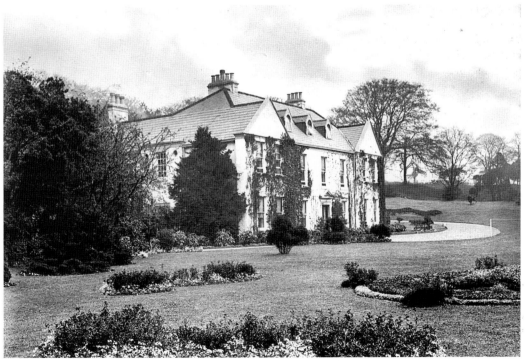

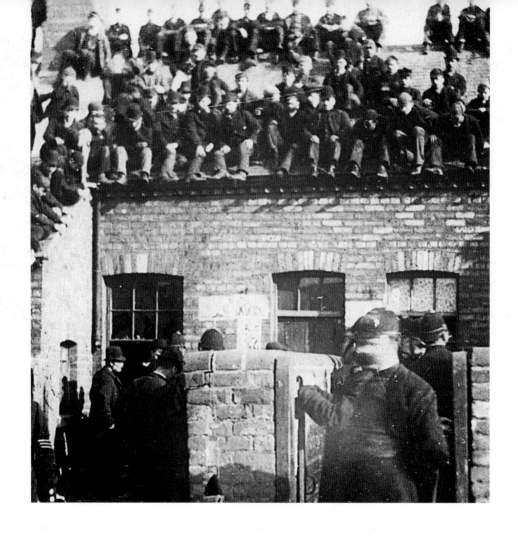

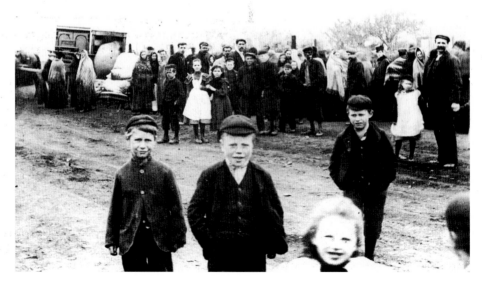

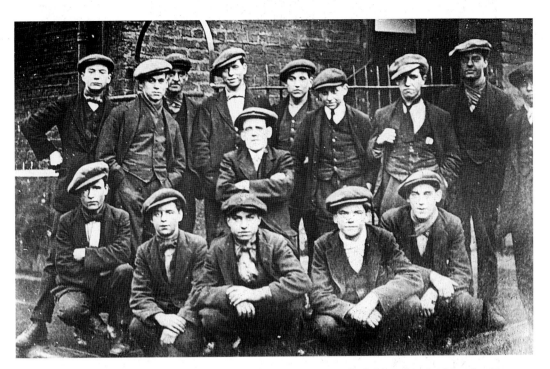

Men and boys at the Silksworth Colliery. The colliery originally belonged to Lord Londonderry but after 1946 it belonged to the Lambton, Hetton and Joicey Collieries.

Opposite, above: Bailiffs carry out an eviction at Silksworth. This is an incident during the Great Eviction Strike of 1892 over the right of deputies to join the Durham Miners' Association. About 1,550 men and boys were out of work as a result and Lord Londonderry had eviction notices served. Here is an eviction taking place with candymen, guarded by police, breaking into miners' cottages in order to carry out the possessions of the residents amidst the jeering of the miners and their families. The word 'candyman' apparently derives from the name for itinerant rag-and-bone men who collected old clothes etc. for the price of sweets but who were prepared to turn their hands to any sort of business.

Opposite, below: Silksworth Evictions, 1892. The possessions of evicted miners are on the roadside and worried womenfolk are standing together wondering how to take care of their families. The men and boys seem to find the situation quite amusing. Many of the evictees responded by carrying back their furniture to the houses where the doors had been left open – the police stopped this though. In some cases the miners' families filled the drawers with stones to make them very heavy for the candymen to lift, and also covered the curtains in cayenne pepper. The strike spread as other Londonderry pitmen came out in sympathy throughout the area.

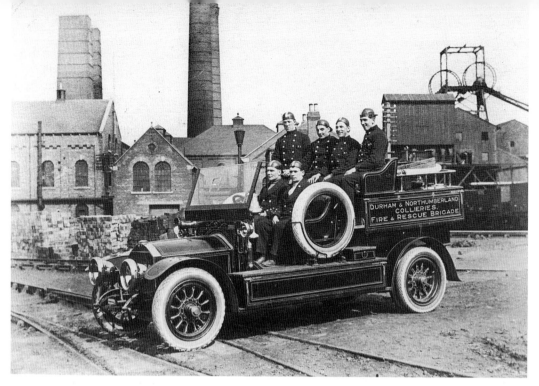

Silksworth Colliery fire engine, 1903 – part of the Durham and Northumberland Fire and Rescue Service. The taller chimneys of Silksworth Colliery can be seen here.

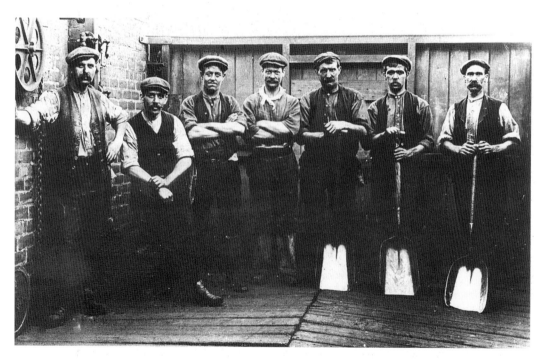

Silksworth Colliery, boiler house stokers, 1900. The boiler house worked the engines. There are hoses on the left.

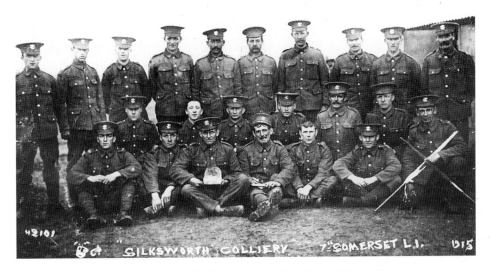

Silksworth men in the Somerset Light Infantry in 1915, 7th Battalion. There were many men from this area in the Somersets for some reason – nothing to do with the claim that the Durham Light Infantry was 'full'.

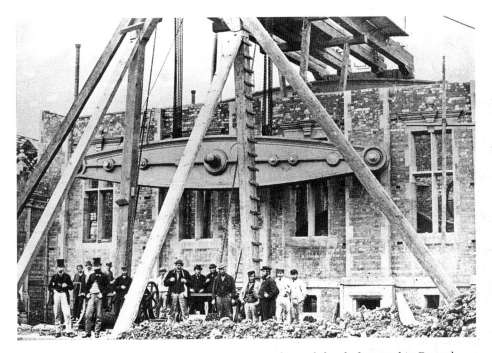

Construction of Ryhope Pumping Station, 1868. Sinking of the shaft started in December 1865, then in April 1866 adverts for tenders were put out for the construction of the pumping station. The two engines were provided by Hawthorns of Newcastle. The engine beams are massive, being about 22 tons in weight. In this picture one of the beams is being hoisted into place. Construction was completed in early 1869 at a final cost of £58,416.

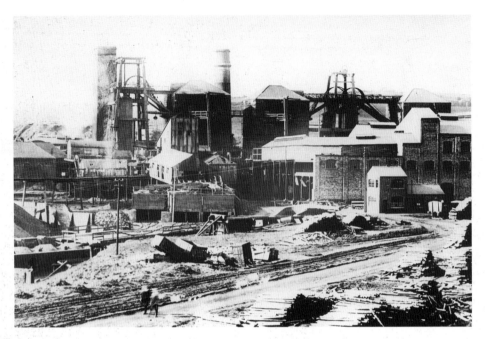

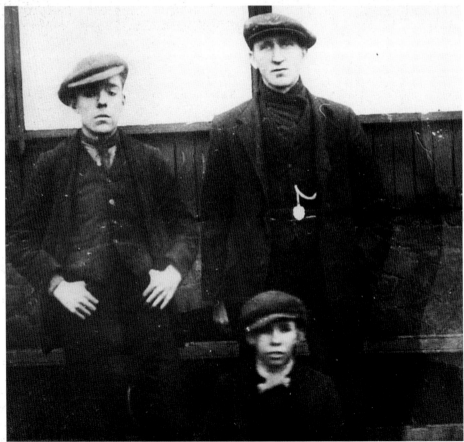

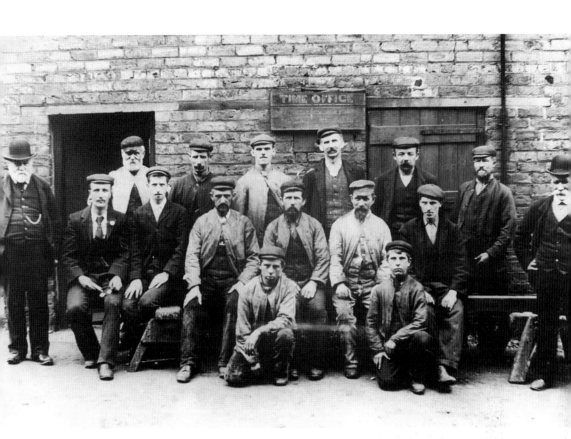

Ryhope engineers, managers and workers, 1890. The man on the left might be a 'keeker' or foreman – the headgear is an indication of status. There will be blacksmiths and winding engine men in the group. Certainly in the case of winding engine men it was common for the job to be passed on from father to son. The Time Office was where the miners clocked in and out of work and discs were used to identify who was above and who was below ground at any time.

Opposite, above: Ryhope Colliery, which had a poor reputation for accidents and fatalities. This photograph shows Ryhope in 1901; the last load of coal taken from here was in 1966. One former miner contrasts an afternoon on Ryhope Beach with working at the pit: 'The most hateful thing was I had to go to work at the pit, Ryhope Colliery. The building had all the windows blacked out, and there was a lot of coal dust. Going up the road to the pit that beautiful Friday afternoon, after that enjoyable afternoon on the beach, was one of the most depressing times of my life.'

Opposite, below: Ryhope miners, possibly from the same family, 1925. There were four basic levels of employment in the mines: the youngest boys worked as trappers opening and closing the doorways along the underground roads, drivers would tend the horses drawing the coal, putters pushed the coal tubs along the tramways from the coalface until the drivers took over, and the hewers hewed the coal from the face and were paid on a piecework basis. Fathers could usually get their sons jobs in the pit. The boys might leave school on Friday and be down the pit on Monday.

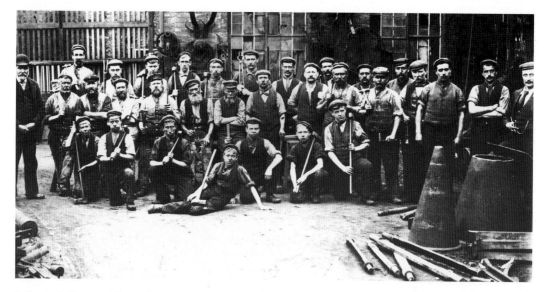

Ryhope Colliery smiths and engine-wrights, 1900. On the left is the foreman. These men were responsible for repairs in the shaft as well as on the railways and will have served on-the-job apprenticeships. There were also night classes available at Ryhope School for men who wanted to get their 'tickets' to become surveyors etc.

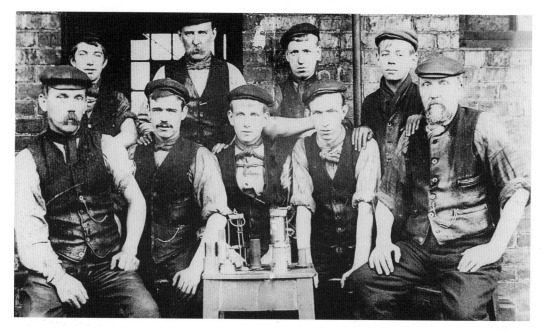

The lamp cabin, 1905. These miners have a couple of lamps in front of them. One of the lamps has been stripped down and the gauze has been taken out. Sunderland was one of the centres of mining lamp technology. There were three major pioneers of early miners' lamps: Humphrey Davy, George Stephenson and William Reid Clanny, who was a prominent Sunderland physician. The Clanny lamp was popular amongst miners in the region but it was the Stephenson or Geordie Lamp which became the standard lamp.

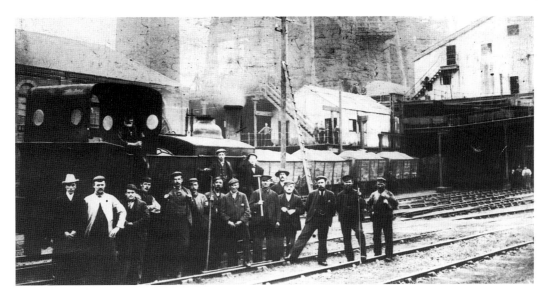

Ryhope Colliery shunters and waymen, 1905. The coal was carried by rail to the staithes. The waymen are holding hammers and other implements used to keep the railway in shape. In the background is a 'tankie' engine.

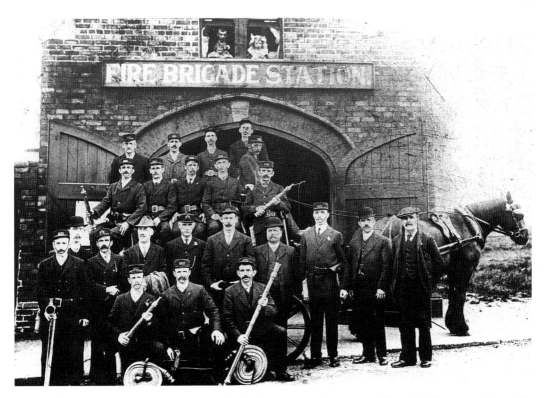

Ryhope Fire Brigade Station, 1908. The building, in Burdon Lane, still stands. These men pictured here are volunteers. Some of them are holding nozzles and they are being observed from above by a man and two girls.

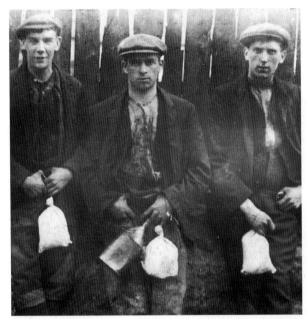

Left: Ryhope miners with bait bags, 1930. One also has a tin water flask. The bait bags seem rather unusual as miners usually had bait boxes. Apart from anything else there were lots of rats and mice underground.

Below: Ryhope women in a protest march in the 1930s. The procession was following the summons of 829 miners for alleged breach of contract as a sequel to a Ryhope Colliery dispute. This march is led by members of Ryhope Labour Party Women's Section. There are coal pickers alongside them with their bicycles and Christchurch in Stockton Road is in the background. They are on their way to the Sunderland Police Court.

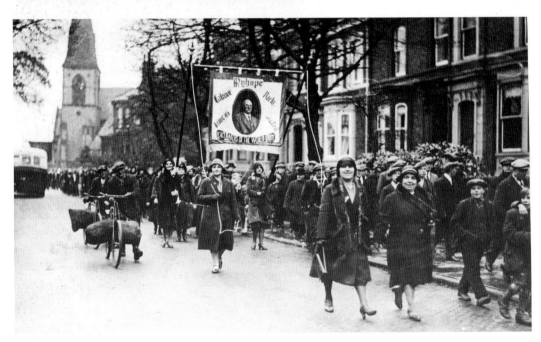

Opposite, below: Ryhope Co-op female staff, 1916. The men will be at war. These women, most of whom would have left school at fourteen, were required to pass a written exam to work here. Clean living, respectable and from a good home were the qualities sought, but it helped if parents were members. Most of the employees were women but some departments, such as hardware, might have a mostly male complement since the view was that men were preferred for advice on such items.

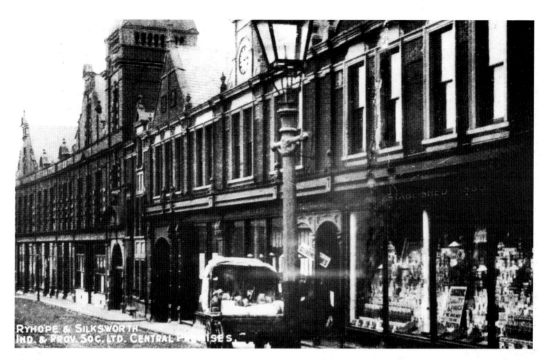

Ryhope and Silksworth Industrial and Provident Society, founded in 1865. There were various branches as well as the main centre at Ryhope. The twice yearly 'divi' was an important supplement to the incomes of members. 'Quality and Price are not to be beaten' is the proud motto and there is a clearance on here. The Co-op was said to supply 'Everything from a candle to a coffin.' As well as shopping in person at the store, groceries and other items could be obtained by putting in an order and having it delivered by the store cart. The main Ryhope Co-op also had a restaurant.

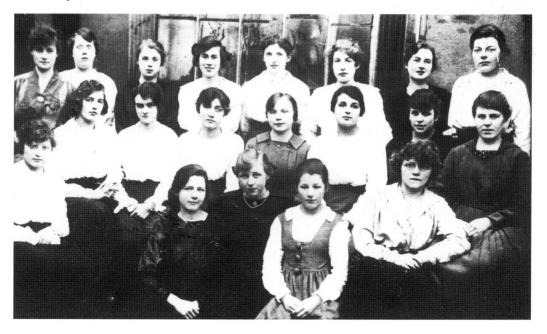

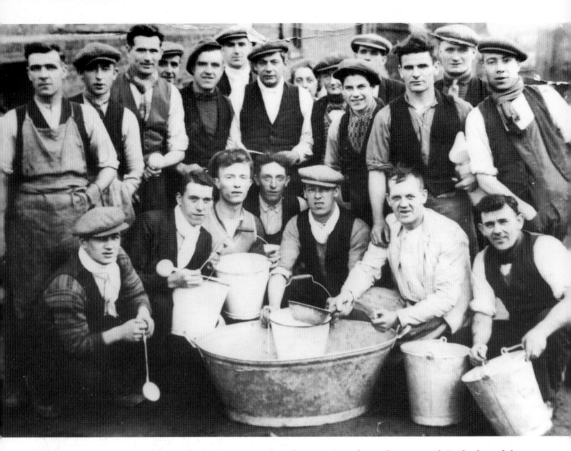

Ryhope Soup Kitchen during the 1926 General and Miners' Strikes. The General Strike lasted for several days and was in support of the miners in their demands for 'Not a penny off the pay. Not a minute on the day.' After the General Strike though, the Miners' strike continued.

6

LIFESTYLE AND LEISURE

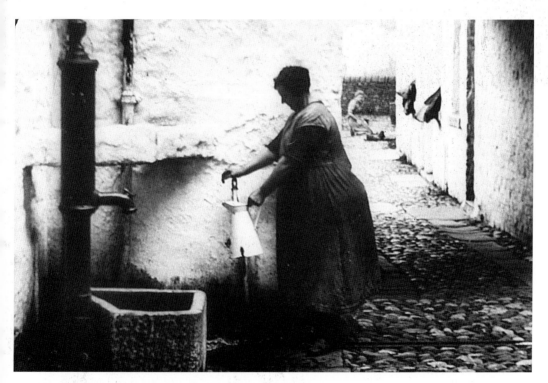

A woman is taking water from a communal supply in an enamel jug. It is not clear what the woman in the background is doing. By 1869 a public health report claimed that Sunderland had a 'larger and better supply of water than perhaps any town in the kingdom.' Communal supplies like this were the norm though.

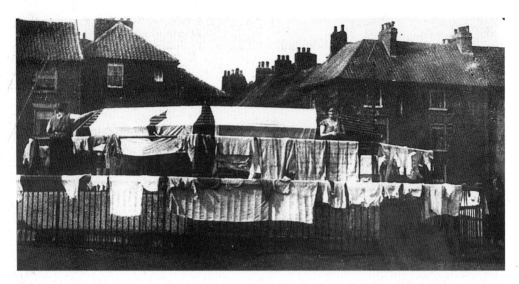

Town Moor bandstand used as a clothes line, 1935. The bandstand served all sorts of purposes other than the obvious one: 'As a boy in the 1920s I spent hours playing on and around the bandstand ... The robust structure withstood the treatment it received from us children climbing about and swinging on the metal work. A forerunner for the modern children's climbing frame, it was the Mecca of dancing for East Enders – many a pair of shoes were worn out due to the Waltz, Foxtrot, Boston Two Step. The bandstand was frequently used – once a week on a Wednesday evening, during the summer months.' (Alfred Hanmma)

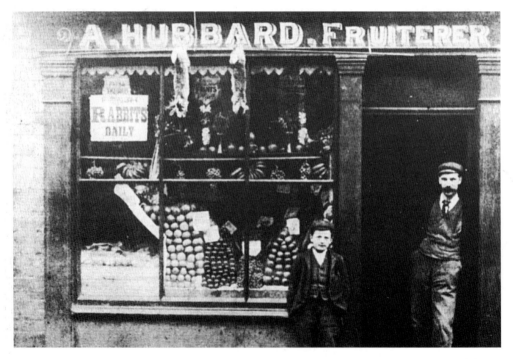

A. Hubbard, fruiterer, Southwick. Also 'rabbits daily' according to the sign in the top left of the window. Mr Hubbard hardly looks rushed off his feet.

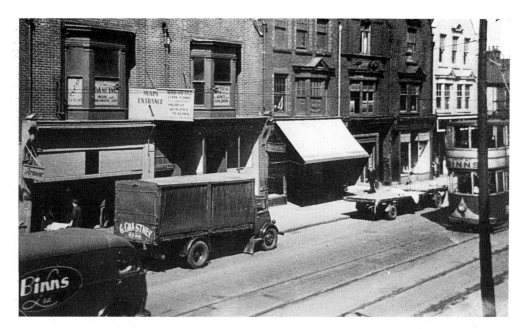

Binns had their own garage and sold cars in Vine Place. Here is a Binns vehicle and also one belonging to C. Chastney. The signs in the windows above are for Windsor Hall: 'Learn to Dance', 'Highest Qualified Teacher', 'Dancing, Music and Dramatic Art' and 'Adults and Children'. Beneath is the Kingdom Hall.

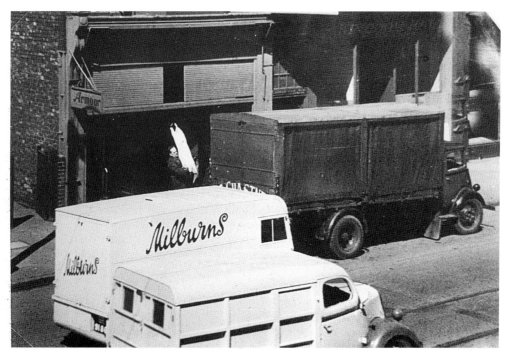

Milburn's were long-established Sunderland high-class bakers and confectioners. Alongside, a Chastney's van seems to be being loaded with meat.

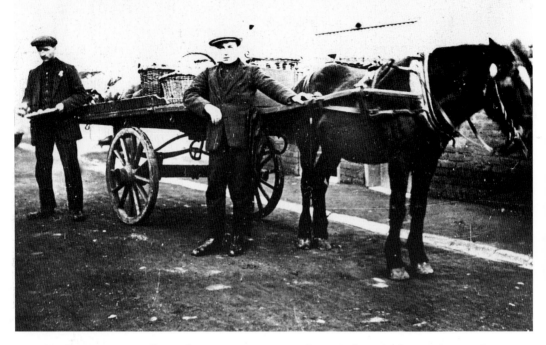

J. Frecker fruit cart, New Silksworth area, 1914. Most produce was brought door-to-door on flat carts like this. Jack Frecker had a shop in Blind Lane; he also had a contract with Sunderland Rural District Council to clean out ash pits. Best not to enquire about hygiene!

Opposite, above: The Covered Market. Before the Second World War the main covered market in Sunderland was the 'old market', which started in 1830. It occupied an area between High Street East and Coronation Street. By 1930, when the market celebrated its centenary, there were forty-seven shops and nineteen stalls which sold everything from fresh produce to second-hand clothes.

Opposite, below: W.H. Garbert's, Pallion, probably before 1914. The linked grocery and confectionery shops were opened in St Luke's Terrace, *c.* 1900. They were very popular with Pallion shoppers for years. Garbert's also organised an annual treat for local schoolchildren with an outing and free cakes, sandwiches and tea. At this time everything was individually weighed and packed. Lard, margarine and butter were all cut to size according to the amount required.

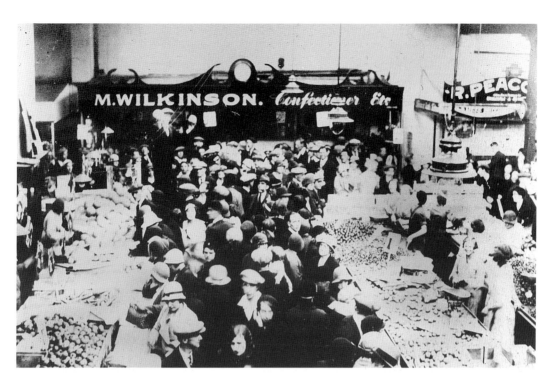

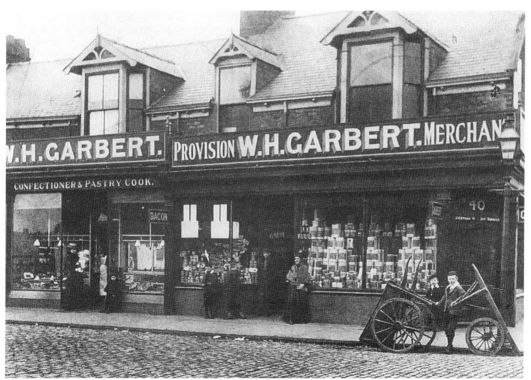

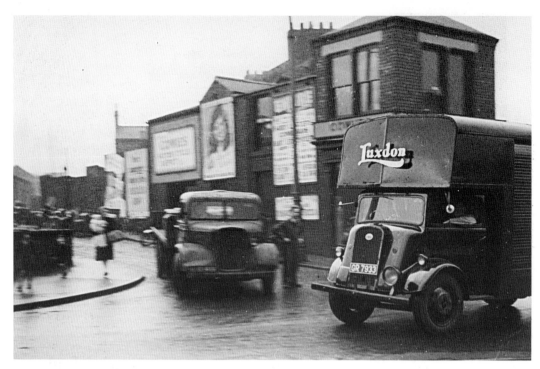

A Luxdon Laundry van, 1949. For generations the Luxdon Laundry kept the clothes of Wearsiders 'clean and bright'. During the Second World War the firm processed 10,000 bundles of soldiers' clothing a week as well as 5,000 household bundles. The service extended to the whole of the North East, and included all of the big hotels. The factory was destroyed by fire in 1961 and rebuilt, then moved to Fulwell Road in the 1980s. More recently it moved to the Sunderland Enterprise Park. It was sold, then went into administration in 2007.

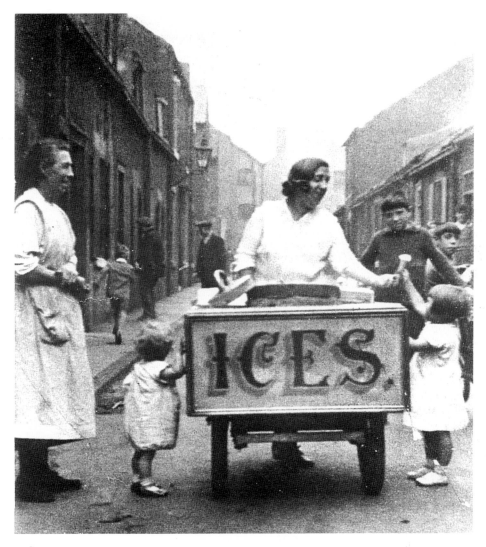

Lizzie Valente selling ice cream in Northumberland Place, 1930s. 'In and around Sans Street there seemed to be a lot of Italian families ... All of these Italians made their ice cream in their own houses, then went around the streets of Hendon to sell their halfpenny ice cream cornets in their handcarts and they all seemed to make a good living out of it. I remember very well one of the Minchella's lads, the one called Tony, singing at the top of his voice – he had a real delightful voice.' (N. Potts)

Opposite, below: The muffin man in the 1920s. The muffin man was another of those itinerant street traders who have disappeared now. The sign on the corner though is that of a dentist. Visits to the dentist must have been awful experiences: 'In 1933 I started school. Like many five year olds, I had to get teeth out ... everyone had bad teeth. Mam took me to John Street, the dentist had his surgery there. I had to get gas. Lots of other five year olds, and their mothers, were milling about. After I came round I was given a white pad to hold over my mouth. Everyone got a white pad. Everyone spit blood. John Street pavements were all spits of blood ...'. (Jean Rochester)

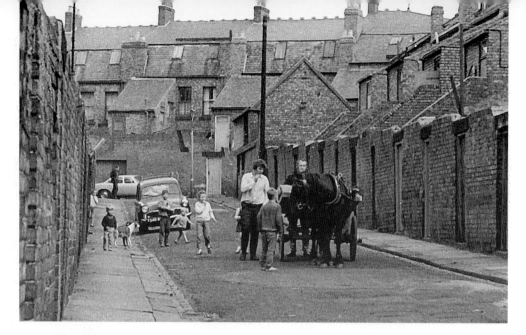

Rag-and-bone man, back lane of Adelaide Terrace. Back lanes had a very important role in the lives of children since they would play there for much of the time. The rag-and-bone man shown here represents a form of street commerce which has now largely disappeared: 'Then there was the 'Rag Man', he came around the back lanes and for a bundle of rags we were given a baby chicken or a goldfish ... Then there was the fish barrows, pushed round the streets, laden with fish and willicks [whelks]. His call was "Calla Herring". A big bag of willicks was 3*d*.' (Anne Hansen)

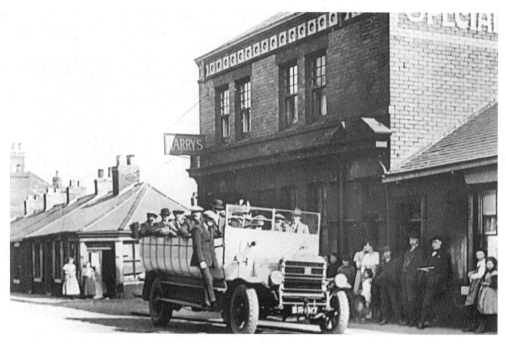

Charabanc tour at Deptford, 1920s. As a result of the war, many men had learned to drive and there were a lot of cheap vehicles available to small bus companies.

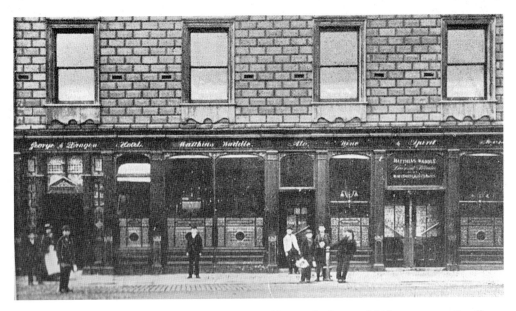

The George and Dragon in High Street West – an old inn which served Bishopwearmouth village since before its great growth in population. In 1891 the Palace cinema was built next to it and it was considerably improved. Amongst other things it was advertised as having 'the finest billiard room in the North of England' with five tables and the well-known player Mr Benneworth in charge. There was also 'electric light throughout!' The Crowtree Leisure Centre stands on this site now.

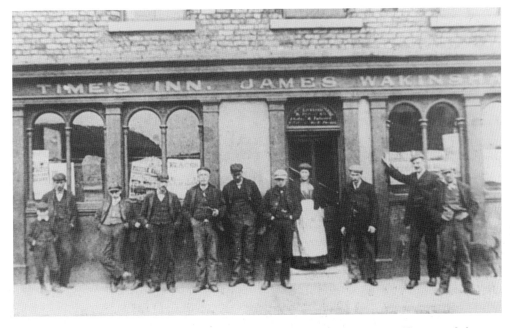

The Time's Inn in Wear Street, Southwick, 1900. It closed after the First World War and the building was eventually used as a store by Pickersgill's. Then in the 1980s it was rebuilt and reopened as the Time's Inn.

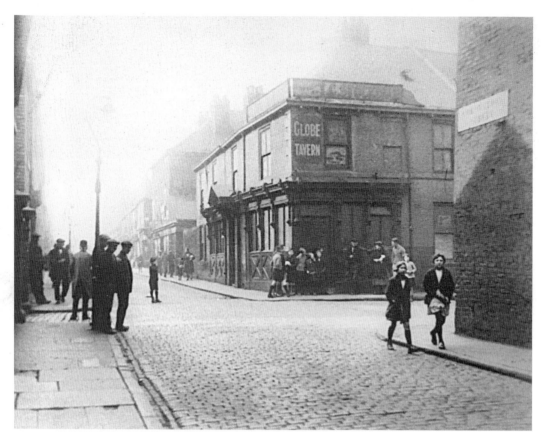

This is the Globe Tavern in Huddleston Street, Monkwearmouth, confusingly close to a Globe Inn for some time. In the Monkwearmouth Shore area there were over twenty pubs in the nineteenth century because this was a very busy shipbuilding area.

Opposite, above: The interior of the American Bar in Barrack Street, *c.* 1900. The customers seem to have disappeared when the camera was produced – but their drinks have been left for them. Hand-operated pumps were just being introduced; before that development beer was brought from the cellar in jugs or served from barrels behind the bar. The American Bar had both pumps and barrels. There are remarkably few pictures of pub interiors.

Opposite, below: Wesley Hall, Trimdon Street. The Wesleyan Methodists began from the 1840s to accept state aid and provide their own schools with 'an education which may begin in the infants' school and end in heaven ... to fill the world with saints and heaven with glorified spirits.' They built five schools in Sunderland, including one attached to the chapel in Trimdon Street. It is not clear what Emmerson's sold but the window appears to be full of glass jars. (T. Greener, Wesley Historical Society Bulletin NE, August 1981)

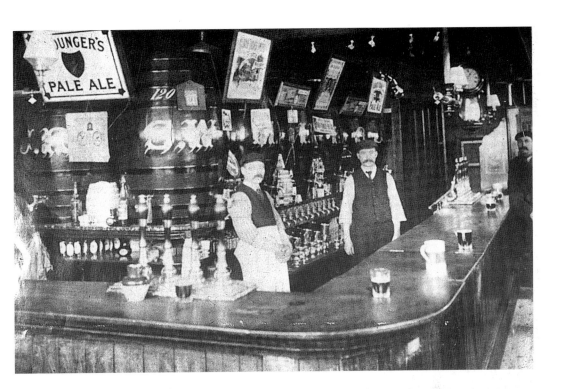

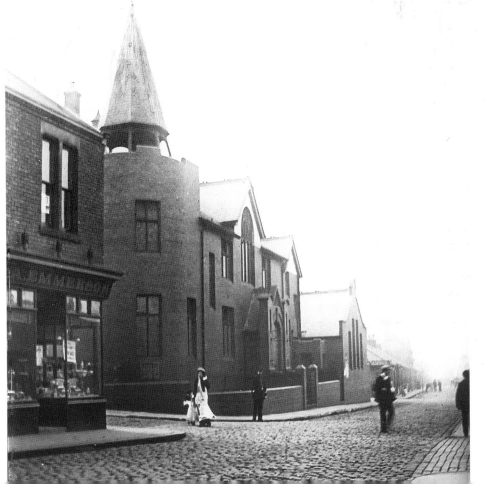

91

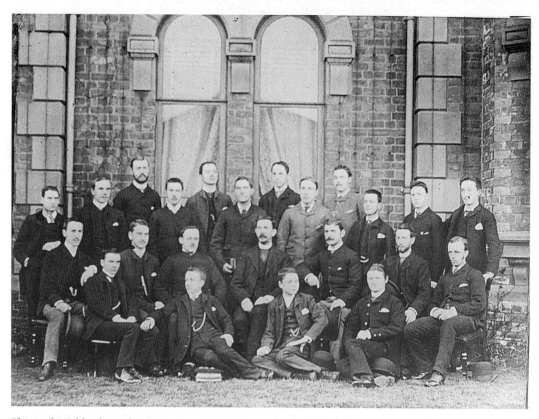

This is the Bible class of W.H. Paris in 1886. It was also a Bethesda group.

Opposite, above: Bethesda Mission. This will be the Bethesda Free Chapel in Tatham Street which was established in 1844-5 as a result of the secession of Anglicans into nonconformity. It looks as if this is part of some sort of appeal to help poorer people overseas – the slogan reads 'Come Over and Help Us' and children are holding a sign which reads 'Central and South America'. On the left is a picture of the Taj Mahal; on the right is a map with the words 'Look Bethesda's Arrows'. The adults and children are dressed up in the clothes of different peoples of the world and at the bottom it says 'Asia Africa America Australasia'. The object in the centre is a gong.

Opposite, below: The Al Flush Band at the Rink: 'I was seventeen years, it was the 1950s ... The Rink had a big band, led by Al Flush. He played the best music of the day. They didn't sell alcohol in dance halls only soft drinks or cups of tea. The Rink was the most popular place, especially with the young generation. The Rink was my favourite Saturday night out. I didn't finish work until 6 o'clock, it didn't take me long to get ready. I remember wearing a full black skirt, mid-length, tight short top and waspie belt, nylon stockings ... It was mostly ballroom dancing ... Many met their life partners meeting like this. I met my husband at the Rink.' (Moira Lawrence)

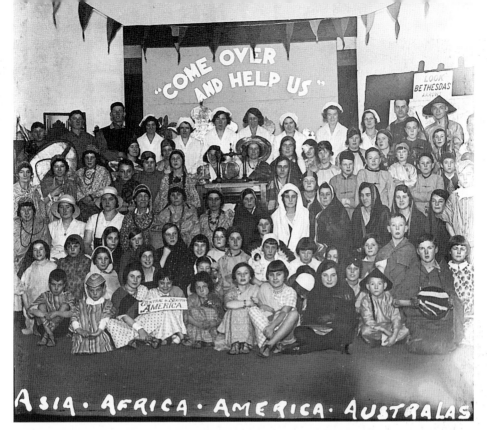

"COME OVER AND HELP US"

LOOK BETHESDAS

ASIA · AFRICA · AMERICA · AUSTRALAS

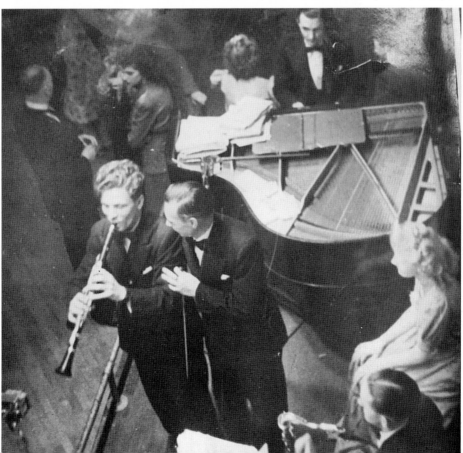

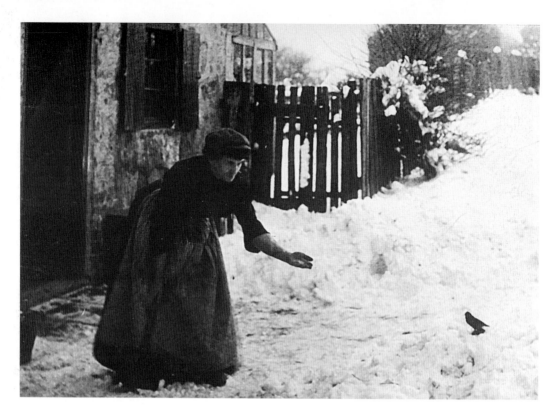

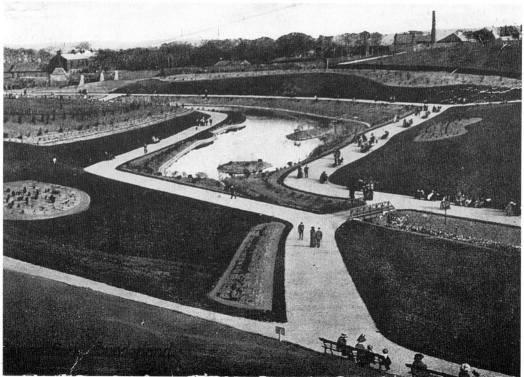

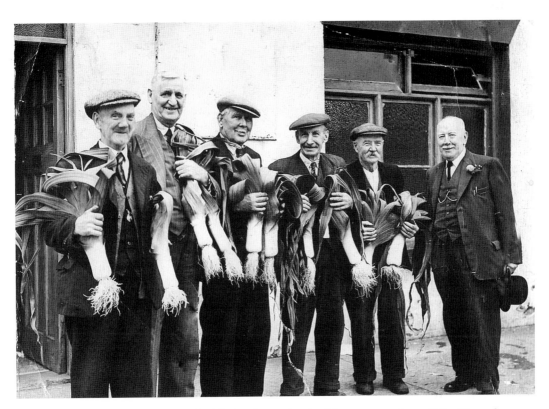

Leek show at Southwick Social Club: 'Leek growing is still a very popular activity. The only countryside we ever saw was when Dad walked my sister and I down [to] where he had an allotment. We would spend a bit of time pottering about and playing before leaving, picking a bunch of flowers for Mam. Dad always put on a lovely show and grew lots of vegetables. Before returning home we would gather watercress to go with the lettuce and tomatoes we had picked for tea. Mam would be waiting with a can of Spam and a small loaf of bread cut and thinly spread with marge. We did this every week.' (Joan Quinn)

Opposite, above: Mrs Weightman with a tame robin, Pemberton Hall Farm, 1900. Pemberton Hall Farm stood in the area of the modern Barnes Park. The head of the company when the Wearmouth Colliery was sunk was R.L. Pemberton of Barnes and initially the colliery bore his name. The Pemberton family owned the land which became a park in 1909. They also owned Hawthorn Dene, where they had a large house and a private railway halt, and also Ramside Hall, which is now a hotel.

The first public park in Sunderland was Mowbray Park, opened in 1857. Barnes Park (pictured here) was opened in 1909 and was extended in the 1950s. Backhouse Park was opened in 1923 and Thompson Park in 1933: 'As a youngster I spent many happy days in Barnes Park with my mam and friends. We climbed onto the canon, listened to the bands and of course fed the ducks. Unfortunately one day a 'friend' pushed me into the slimy end of the duck pond. Soaking wet and quite smelly I was marched home to Ormond Street by my mam. On reaching home my Dad saw the funny side of the situation, and we all ended up laughing.' (Norah Scrafton)

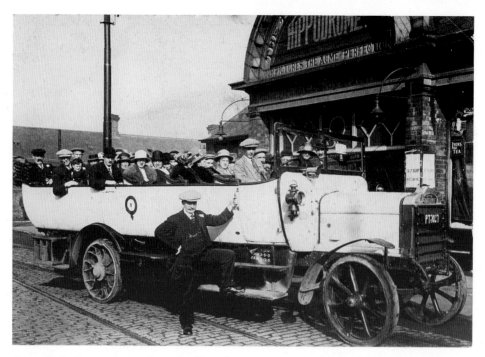

Annual trip for pensioners from the Hippodrome cinema, 1922. The 'Hip' still stands in Stewart Street but it was the Rex Bingo Hall at the time of writing.

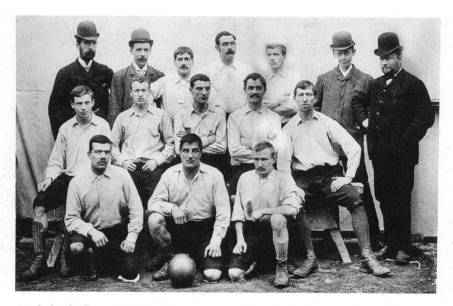

Sunderland Albion, 1889/1890 season. Sunderland schoolteacher, James Allan, founded the Sunderland District & Teachers Association Football Club in 1879. The name was changed to Sunderland Association Football Club in 1881. However, Allan grew dissatisfied with the changing attitude towards professionalism in the club. He left to found Sunderland Albion, and the two Sunderland clubs were rivals until Albion's demise in 1892.

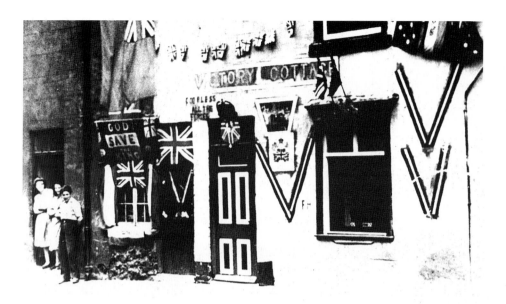

Victory Cottage, 1945 – it speaks for itself! It is not clear where this is – but is alleged to be in the East End area. It is covered with great V signs, Union and Commonwealth dominion flags and signs such as God Save the King and God Bless all the Forces.

This is Church Walk, one of the most historic quarters of Sunderland. On the right is the Donnison School, which was established with a bequest in 1764 from Elizabeth Donnison to provide free education for thirty-six poor girls. It was extended in 1827 with the addition of a house for the mistress and another room. Behind it can be seen the Trafalgar Square Almshouses, built in 1840 for aged Sunderland seamen and their wives and widows. On the left is the Sunderland workhouse, built in 1740.

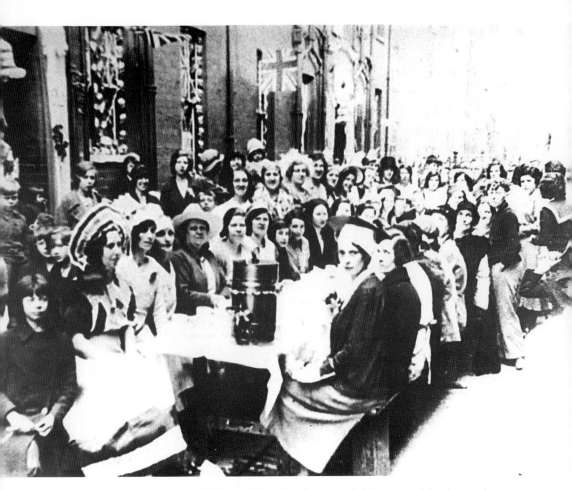

A 1945 street party to celebrate VE Day, although, of course, fighting was still going on in the Far East. Nearly all of the people in the picture are women although there are a couple of children. The houses in the background have been profusely decorated with flags and bunting.

7

SOME WORKERS

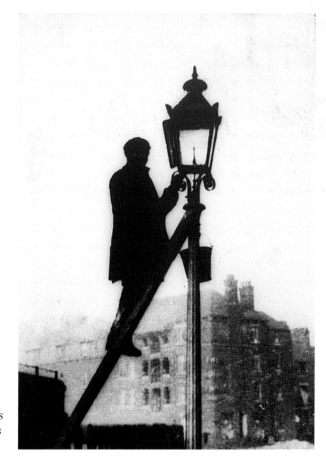

The man in this picture appears to be cleaning the glass of the gas lamp. The Bishopwearmouth Improvement Commissioners established a gas company in 1823 and the Borough Corporation took over gas provision from 1854. The town's street lighting was gas until the 1920s, when it was replaced by electricity.

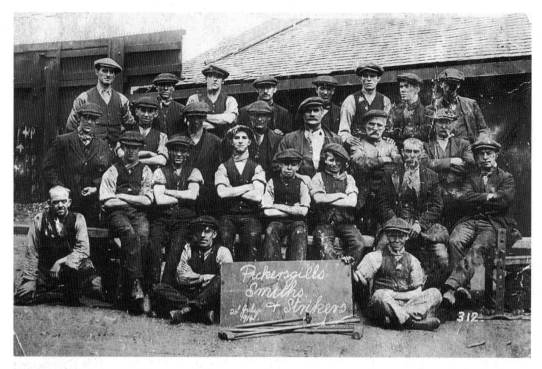

Blacksmiths and strikers at Pickersgill's shipyards, July 1914. Pickersgill's started to build ships at the North Dock in about 1838 but moved to Southwick in 1851. Amongst other things, they built the last wooden ship ever built at Sunderland. The firm developed a reputation for fine barques and fully rigged ships, many of which were involved in the Chile guano trade and carried coal from New South Wales. The date of this picture is 24 July 1914 – war is just days away.

Opposite, above: This picture was taken during the Second World War. Workers' Playtime appeared live from different locations. There is a man playing an accordion on the platform. Some performers, who were to become very famous later, appeared on the programme.

Opposite, below: Joiners at Robert Thompson's shipyard, 1882. The 1880s was a period of depression. The *Shipping World* remarked that the trade was never before 'in such a wretched state' and added, 'the present suffering is among a class of highly respectable artisans, self reliant, proud workmen who will endure long, rather than disclose their poverty and want'.

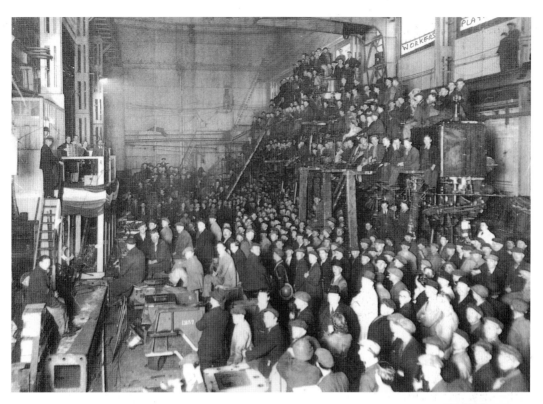

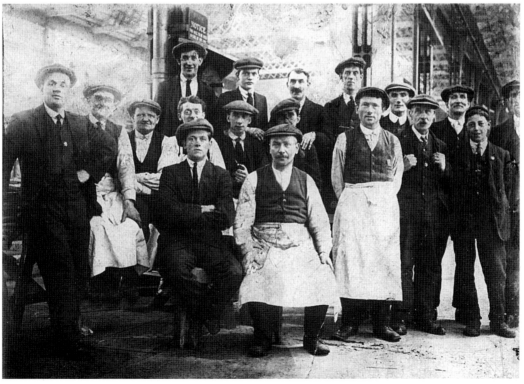

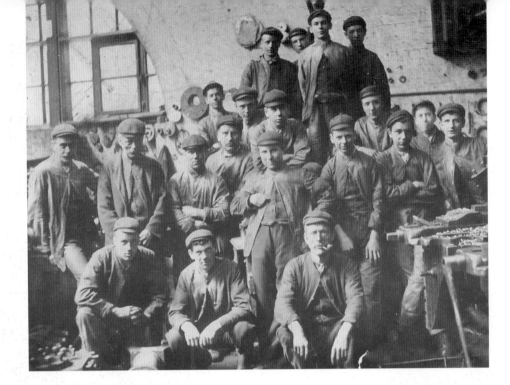

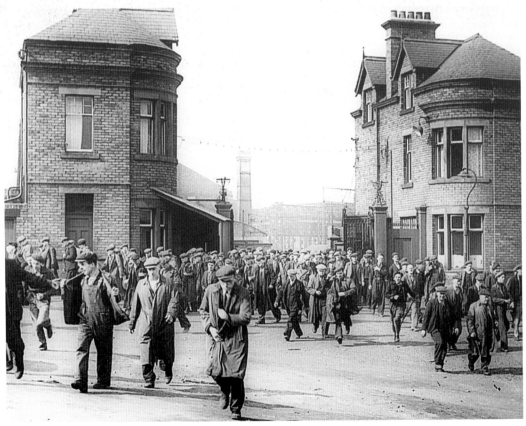

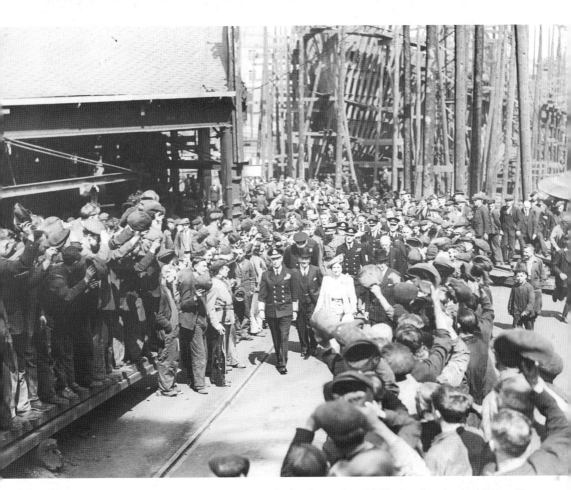

Visit by King George VI and the Queen to Doxford's shipyard in 1943. A solitary man with a rifle stands to the right of the king. He is in civilian clothing but seems to have military webbing.

Opposite, above: These are Sunderland shipyard workers but it is not clear which of the shipyards is represented here. It may also be a very early picture judging from their clothing. It is taken inside a workshop.

Opposite, below: A busy scene as Doxford's shipyard workers leave work.

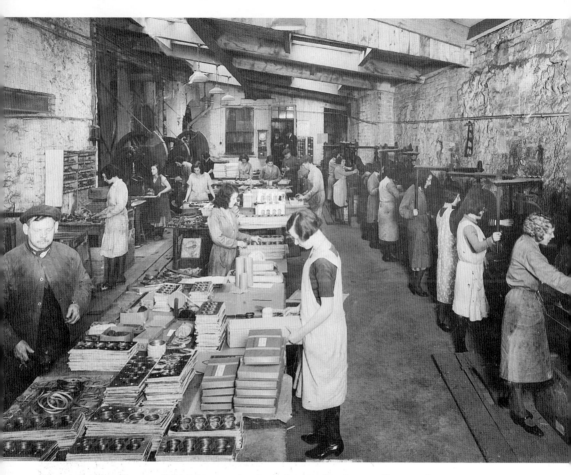

Factory interior, Bonnersfield. This may be the Atlas Works of Sir William Mills, inventor of the Mills Bomb. Mills established the first aluminium foundry in the United Kingdom at the Atlas Works. In 1915, Mills opened the Mills Munitions Factory in Birmingham. His bombs were used exclusively and successfully by the British and other Allies throughout the war and 75,000,000 were supplied. Another of his several inventions was a telescopic walking stick seat!

Opposite, above: The two smartly dressed men may well be rent collectors (Mr Call Backs). This is in the Commercial Road/Norman Street/Fowler Road area. There was a pub on every corner here! The Waverley was on the left. The Burton House (or Stratton's), opposite but not shown, was once run by the grandfather of footballer Raich Carter.

Opposite, below: Road menders near the Gem (right) in Southwick – hard work on a cold day. This is near the junction of Clockwell Street and Mary Street. The Gem was opened in 1913 by James Noble of the local fairground family in a converted chapel building. The town's smallest cinema, it only held 300 and closed in 1924.

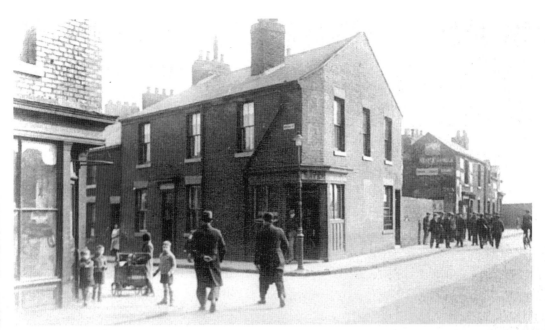

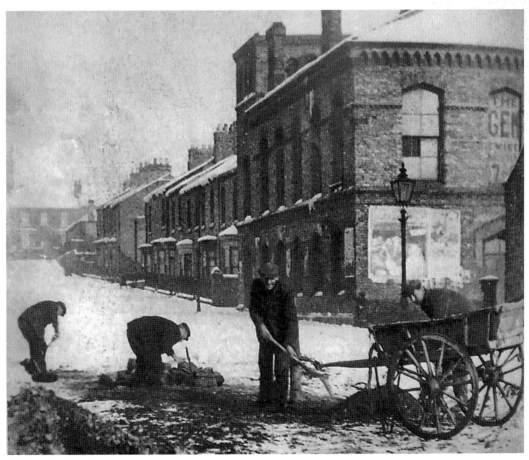

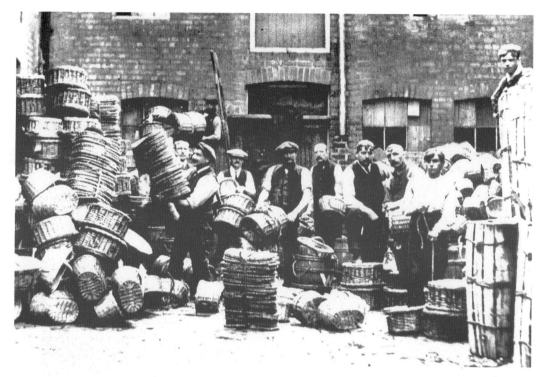

Chalk's fruiterers. Chalk's had fruit shops in various parts of the town and were well known for quality. Mr Chalk has his right foot up, resting on a basket. Until recently, the family were still involved in the supply of pre-packaged fruit and vegetables.

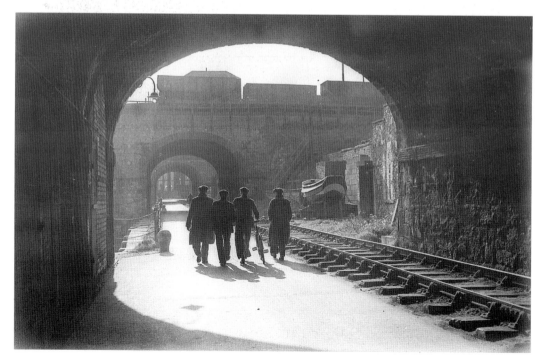

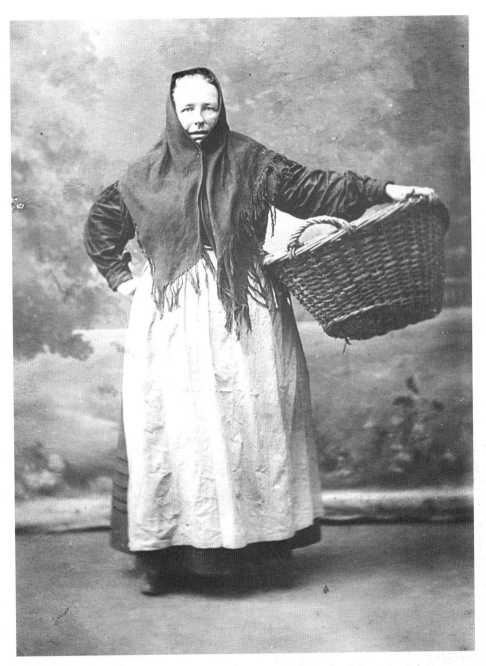

Hannah Lincoln, fishwife. Hannah Donkin was the daughter of a fisherman and was brought up in the Hat Case/Silver Street area of the East End. She married Thomas Lincoln in 1891, and they lived in Burleigh Street. She was a well-known fish hawker or fishwife.

Opposite, below: Dockers on their way to the South Docks, 1950. The dockers are walking alongside the Hendon mineral line. The bridges above them carry rails leading to the coal drops. They don't look as if they are in a hurry.

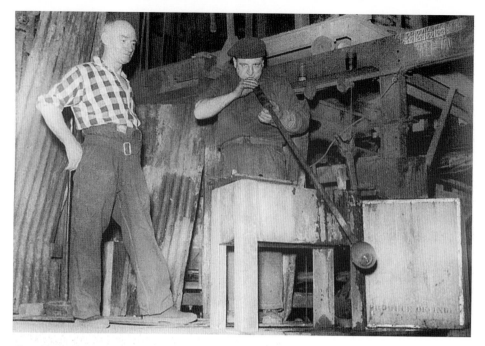

Glass-blowers at James A. Jobling's, 1953. Glassmaking is one of Sunderland's oldest industries. In 1885 James A. Jobling of Newcastle took over a pressed glass firm in Sunderland and went into production. In 1921 Jobling's acquired the right to produce Pyrex in Britain and the Empire. In 1975 the firm was taken over by Corning and in recent years Corning closed and the premises have now been demolished.

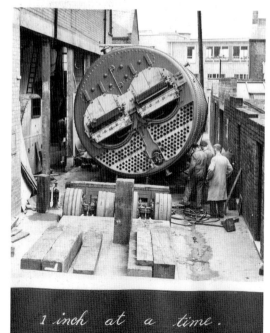

A new boiler in the Luxdon Laundry. Beneath the picture someone has scribbled 'one inch at a time'. The Luxdon Laundry was established in 1887 in Smyrna Place by two sisters – the Misses Ramage. It later moved to Wycliffe Road in High Barnes.

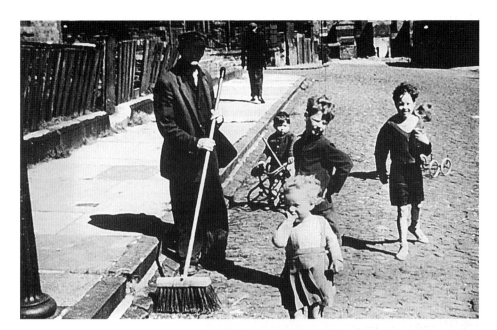

A road sweeper – one of those jobs which would rarely attract the lens of a camera. This is reportedly 1962 but may be a good deal earlier.

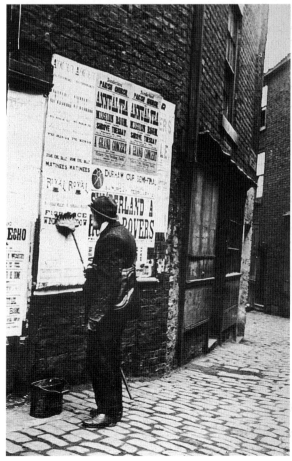

This man is hard at work in the East End of Sunderland. The posters on the wall advertise a variety of things: On the right is one by Sunderland Parish Council to advertise their annual tea in the Mission Room on Shrove Tuesday. There will be a grand concert. Tickets are from one shilling each. On the left are adverts for The Kings and the Royal Variety halls. Lower down is a reminder of the Durham Cup Final to be played between Sunderland Albion and ? Rovers.

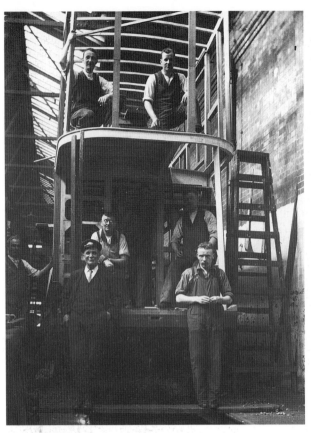

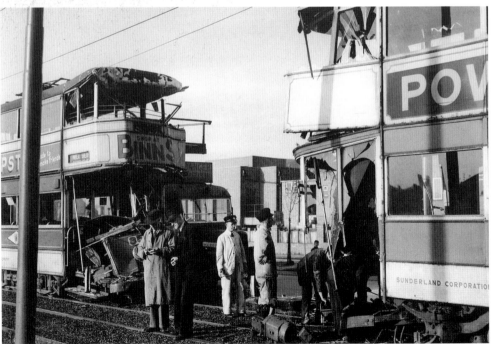

The First World War led to the recruitment of large numbers of women to fill the posts left by men who went off to fight. Jean Newton (badge no.331) was a tramcar conductress. Some of them lied about their age as well. Jean's colleague, May Rich, started at sixteen as the youngest tram driver in Sunderland.

Opposite, above: Construction of trams at Hylton Road Depot. Binns advertisements appeared on the outside of trams from March, 1921. In that year William Waples, the advertising manager for Binns, reached an agreement with the Corporation which resulted in the slogan 'Shop at Binns' being carried on the ends of the balcony trams. This was later extended to all of the trams, and buses in later years. Waples also took many photographs of river and street scenes in Sunderland, and some of the most famous ones are attributable to him.

Opposite, below: Tram accident, Grindon Lane, 1951. The first accident involving electric trams was during the opening procession when No.2 (operated by the vice-chairman of the Tramways Committee) ran into the back of No.1 (operated by the chairman!). Collisions were infrequent throughout the whole period of trams, although as early as 1900 No.10 (driven by a depressed and suicidal driver) ran into the side of No.3. It must be pointed out, though, that trams were remarkably safe vehicles and the number of accidents was very small in relation to the tram-miles covered and number of passengers carried.

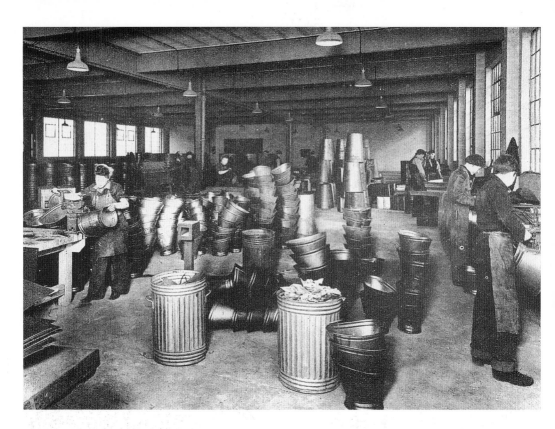

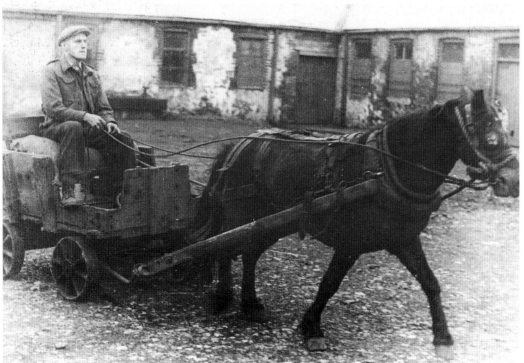

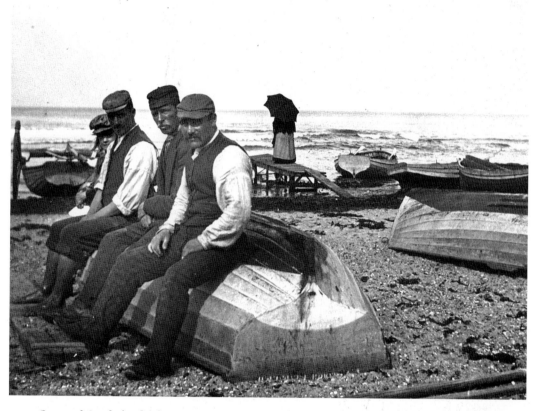

Group of Sunderland fishermen – not working, exactly, but everyone is entitled to the occasional rest. At the far end is a young boy, probably listening to tall tales. The woman on the jetty has an air of *The French Lieutenant's Woman* about her. Of course, Sunderland was once no more than a fishing village. Nowadays there is little to show for it.

Opposite, above: Sunderland galvanisers, 1940s. This was in Lisburn Terrace near Alexandra Bridge. The process of zinc coating involved the use of powerful acids into which goods such as dustbins were dipped. It was quite dangerous, and very dirty work.

Opposite, below: Training a pit pony to pull tub at Ryhope, 1946. An old pitman spoke about the treatment of the ponies: '... now a gallower, people who are not used to pits, would term it a pony; it's an animal that's been used, badly used in some cases, for years and years in the pit, for both hauling the coal out and for dragging the materials in to the working places ... but nowadays they've done away with the ponies and sad to say they've replaced them with human ponies.' (William Calvert)

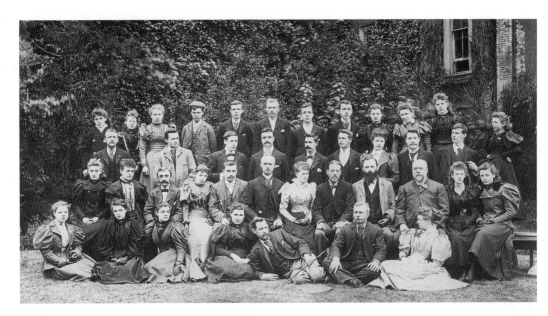

Sunderland postal and telegraph clerical staff, 1897. In 1869 the Post Office was granted a monopoly of inland telegraph business. The staff photograph here includes a good number of young women. Indeed, the later nineteenth century saw increased employment opportunities for young women, educated through the new School Boards. Teaching, department stores and clerical posts such as these opened up considerable possibilities.

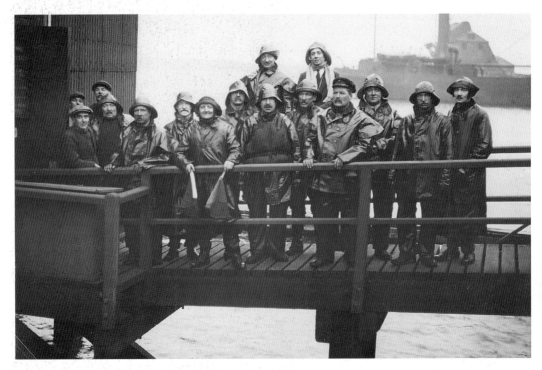

The new piled structure was erected in 1915. Here are the lifeboat crew, wives and supporters.

8

LOTS OF BAIRNS

A small boy on a rocking horse in the backyard. Presumably this is a new toy for the child. There are few pictures of backyards, despite the fact that they played an important part in family life. Here is a description of the contents and layout of a backyard in the 1930s: 'Our backyard had a dog kennel, a rabbit hutch, a rain water barrel [and] a standpipe to supply all domestic water needs. At the bottom of the yard we had a flush toilet and a coal house. We had a 'garden' in two motor car tyres, a clothes line and space to park our bikes. We had a half glass shed with an enamel dish for washing and of course a galvanised bath hanging on the backyard wall.' (Tom Buckley)

Silksworth babies in pushchairs, 1921. The pushchairs look very uncomfortable. There has been a modern debate about whether babies in pushchairs should face their parents and that their development can be affected if they look the way they are being pushed. These are built like battleships.

Silksworth girls with prams, 1928. Just a lovely, timeless picture.

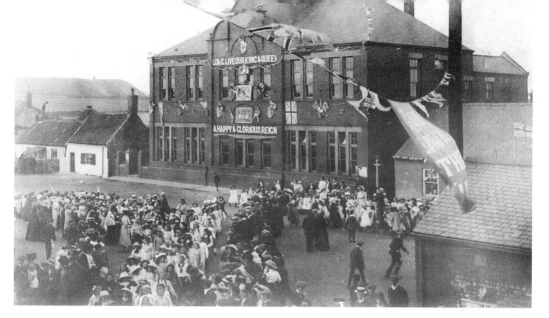

Fulwell Board Infant and Junior School, built in 1877. It could hold up to 350 pupils. The banner says 'Long live our King and Queen. A happy and glorious reign'. This will be the coronation of Edward VII or George V – probably the former. Boys in sailor suits and girls in white aprons are in some sort of procession. Men are wearing straw hats and there are some very fashionably dressed women. At the back right are the infants. One small boy seems to have turned his back on the whole business and wandered off. The school is profusely decorated with union flags, coats of arms, shields and crowns.

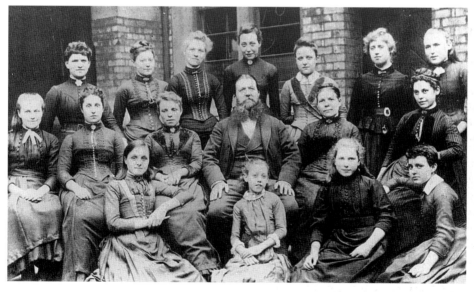

Garden Street School staff, 1890. There is a male head teacher and sixteen women. The young girl in front of him may be his daughter, and the lady on his left is possibly his wife. These are a mixture of assistant mistresses and pupil teachers. The latter would be paid between £60 to £120 per annum depending on qualifications, experience and sex. Female pupil teachers started at about £10 a year but male pupil teachers received £15.

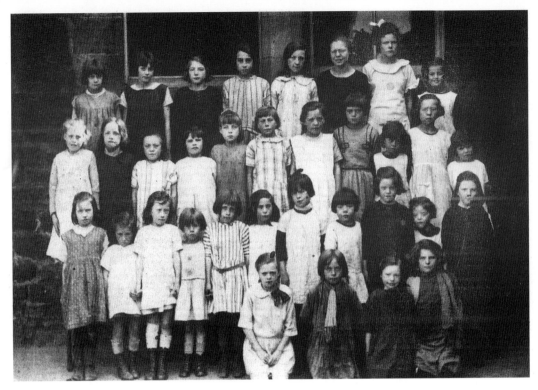

Gray School, 1926. There are thirty girls in this class, with their teacher and possibly an older girl next to her. The Gray School was a large parochial school established for boys and girls in the Sunderland parish in 1808. It was funded through wealthy benefactors and the vicar, Robert Gray. An infants' school was added in 1835. There were two large rooms housing boys and girls separately. Teaching was, at that stage, through the new monitorial system.

Opposite, above: The Forster Education Act of 1870 enabled elected School Boards to 'fill the gaps' in the elementary school provision. When the Sunderland School Board finally ended its existence in 1902, and its powers were transferred to the local authority, it was able to hand over eighteen large schools with over 21,000 pupils. These are children from the Hendon Infant School in 1897. There are twenty-nine in this group with two members of staff. The girls are neatly turned out with starched aprons and the boys have white collars. Barely a smile can be seen – having your school photograph taken was a serious business.

Opposite, below: James Williams Street School, 1914. The girls are wearing fashionable sailor style outfits. They look very apprehensive and the girl second from the left looks as if she is about to burst into tears. The James Williams Street School was the first purpose-built School Board school. It was erected in 1874. Sunderland was revealed as having a deficiency of 7,000 in school places. This school cost £9,000 and held 1,000 pupils divided into boys and girls, and even boy infants and girl infants. It had a prominent bell tower.

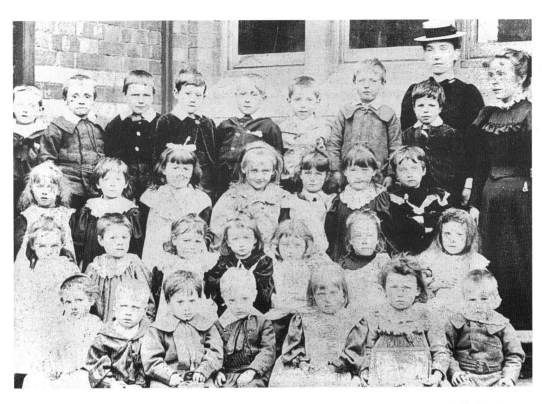

Barnes infants, 1934. Barnes Junior and Infants' Schools were later School Board schools built on Mount Road. The hall and the rooms were well lit by lofty windows but high enough in the wall to counteract idle gazing. The children are learning a dance – only one girl is visible here.

Opposite, above: An infants' class at James Williams Street School, *c.* 1914.

Opposite, below: Ryhope Infants, Class 6, 1919. There are twenty-seven infants here with their teacher looking more relaxed than the Hendon Infants group. The little girl seated second from the right in the front row has just moved her head at the critical point. Ryhope Council built a large block of schools in 1909 which held 1,400 pupils altogether.

Bede School science class, 1930. These are pupils of the Bede Collegiate Girls' School in the junior laboratory. It is not quite clear what the experiment is! The first 'higher grade' school in Sunderland opened on the West Park site in 1890. It adopted the name Bede in 1898, and became the Bede Collegiate School in 1905. It moved to the site on Durham Road in 1929.

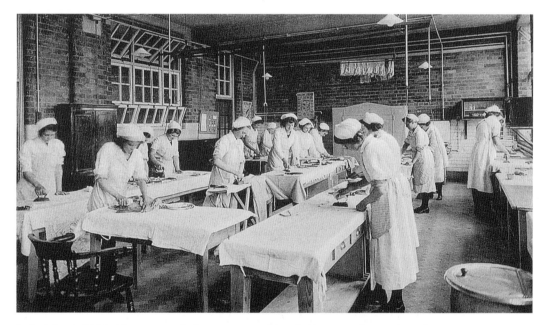

Bede School, 1930. These young ladies are using old style flat irons during their domestic science lesson. Boys would do woodwork and metalwork and never touch a flat iron or encounter a cooker. There were separate schools for boys and girls – although it was impossible to keep them apart! Bede Grammar School was selective until the 1960s, when it became a comprehensive. It enjoyed an enviable reputation in the region for the quality of the teaching and the achievements of ex-pupils who included, amongst others, James Bolam of the Likely Lads and Dave Stewart of the Eurythmics.

These are the smiling boys of Sunderland Orphan Asylum. Legislation passed in 1853 enabled the building of this, although it was not built until 1862. It was the home of young boys for many years who were the orphans of seafaring men and it was run on nautical lines. Many of the boys would make seafaring their profession.

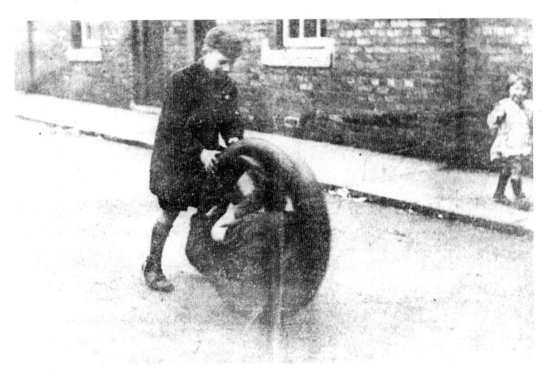

The joy wheel. There is little information about this picture and its quality is poor, although it is known to have been taken somewhere in Silksworth and has something to do with a *Sunderland Echo* competition in 1932. There is a boy tucked into the tyre which is being rolled down the pavement to the delight of the little girl.

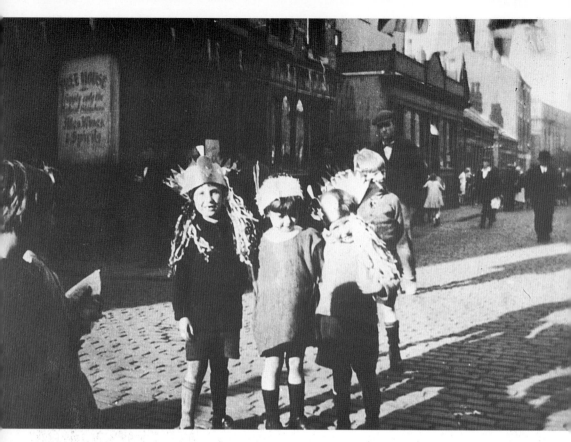

An East End scene. This looks as if the children are dressed for either a carnival or for some sort of celebration as there is some bunting to be seen. It is difficult to date but it might be the 1930s.

Opposite, above: East End children, *c.* 1910. There is no indication as to the reason for the grouping. It is thought to be in the back lane of Addison Street or Robinson Street. The woman on the left looks as if she might be a teacher and the young boy on the right is in a very vivid striped coat.

Opposite, below: A Sunday school trip to Cox Green, 1943. Cox Green was a popular destination for visits by groups like this. Many of these children are holding bottles of drink and it looks as if this cheerful group is about to have a picnic. Church activities such as this were an important element in the leisure of children and young people: 'We used to walk to Millfield station. We went from there to Cox Green. It was only two stops away and you would think we were going to Hong Kong, hanging out of the windows waving away in the train. We would get off the train and march to the field. We would get a bag with sandwiches in and a snowball, a bag of sweets, as many cups of tea as you liked. 'Course our mams went with us. We used to play races.' (Peggy Whittaker)

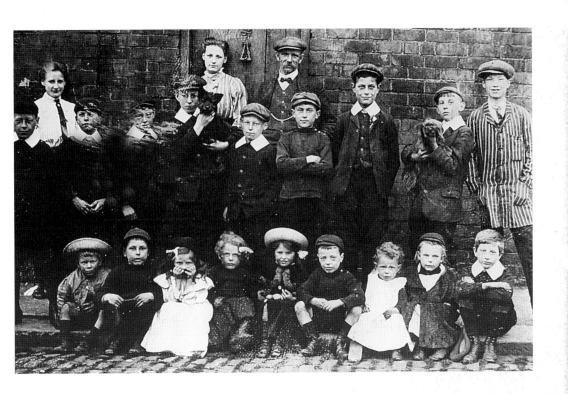

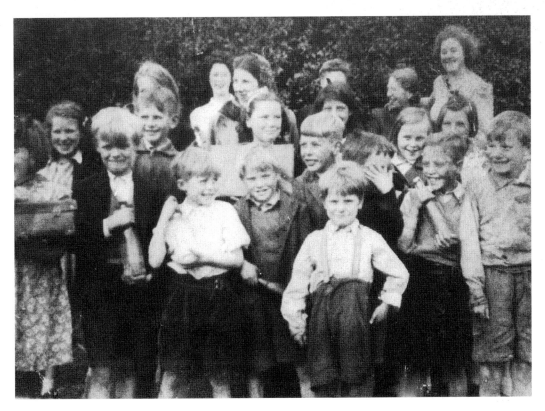

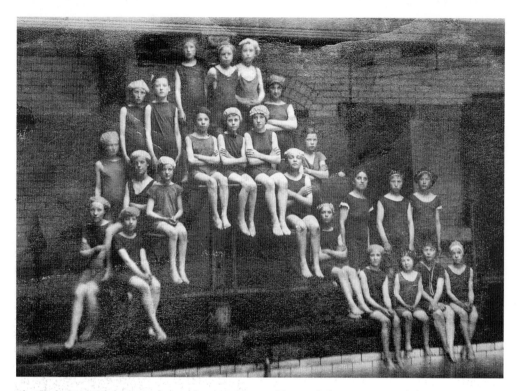

The High Street Baths were designed to provide a public wash-house as part of the programme of public health reform. This picture may be pre-1914 or at least soon after the war. Dave Stewart, who went to Barnes and Bede Schools in Sunderland, has happy memories of eating 'penny dips' after swimming sessions at High Street swimming baths: 'It was bun dipped in gravy with pease pudding on it … When you'd come out of the baths, and your knees were knocking together and freezing, it was the one thing that could really warm you up.'

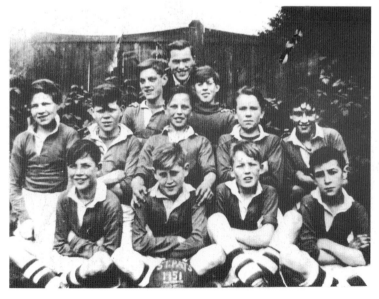

St Patrick's football team, 1951. Catholic schools made a valuable contribution in the provision of education in Sunderland. St Patrick's in Coronation Street was built around 1860 – in fact the school was held in the church for a decade before it transferred to new premises.

Fashionable boys in Ryhope in 1914. Certainly civilian fashions do, on occasion, mimic military clothing and people commonly wear camouflage fatigues today. They are too young to be conscripted thankfully.

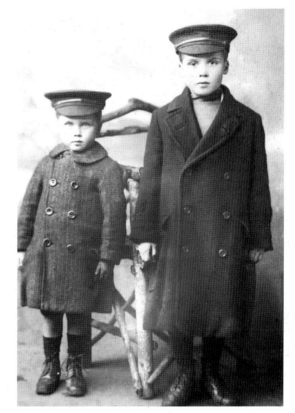

Very smart sea cadets led by their petty officer. Their hall was in Lindsay Road in Hendon. At the time of writing there were calls for the movement to be revitalised in Sunderland.

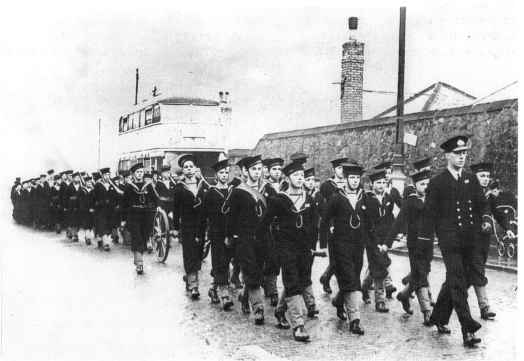

Other titles published by The History Press

Sunderland Memories

JANETTE HILTON AND LIVING HISTORY NORTH EAST

Using many previously unpublished photographs, *Sunderland Memories* offers a compelling insight into the varied history of the city. Sunderland, a historic shipbuilding port renowned for its trade in beautiful, vividly coloured glass, has seen many changes over the last century. Collected in this book are the personal memories of Sunderland people, who provide eloquent descriptions of their city as it once was. Childhood, schooldays and wartime are all recalled, alongside more recent perspectives.

978 0 7524 4491 8

Haunted Sunderland

RUPERT MATTHEWS

Explore Sunderland's darkest secrets with this creepy collection of true-life tales from ghost-hunter Rupert Matthews. Containing many tales which have never before been published, it unearths a chilling range of supernatural phenomena, from the Ryhope Poltergeist and the White Lady of Washington Hall to the glowing grave at Wingate and spectral talking cat.

978 0 7524 4663 9

Sunderland Transport

JOHN CARLSON AND NEIL MORTSON

Sunderland Transport is packed with photos, illustrations and diagrams, plus a wealth of information and recollections from some of those who worked on the vehicles themselves. Also covered are the services of Sunderland Corporation, Sunderland District Omnibus Company and Tramway Company, its follow-on bus operations and those of the Economic bus company.

978 0 7524 5075 9

Ghostly Tyne & Wear

ROB KIRKUP

Drawing on historical and contemporary sources, this selection includes a phantom highwayman at Blacksmith's Table Restaurant in Washington, a *Carry On* film legend who haunts the Empire Theatre in Sunderland, a mischievous poltergeist at the Central Arcade in Newcastle-upon-Tyne, as well as sightings of phantom soldiers at Arbeia Roman Fort in South Shields. Illustrated with over sixty photographs, this book is sure to appeal all those interested in finding out more about the area's haunted heritage.

978 0 7509 5109 8

Visit our website and discover thousands of other History Press books.

www.thehistorypress.co.uk

The History Press